IMPROVISATIONAL THERAPY

IMPROVISATIONAL THERAPY

A Practical Guide for Creative Clinical Strategies

BRADFORD P. KEENEY

THE GUILFORD PRESS
New York London

IMPROVISATIONAL THERAPY: A PRACTICAL GUIDE
FOR CREATIVE CLINICAL STRATEGIES

Copyright © 1990 by Bradford P. Keeney

Published by The Guilford Press
A Division of Guilford Publications, Inc.
72 Spring Street, New York, N. Y. 10012

Printed in the United States of America

This book is printed on acid-free paper

Last digit is print number 9 8 7 6 5 4 3

Library of Congress Catalog Card Number: 91-074164
ISBN 0-89862-486-X

Contents

Acknowledgements

This book would not have been possible without the group of students and colleagues who first heard and practiced these ideas and strategies. They were part of a training and research context in which their participation helped shape the formation of improvisational therapy.

A special note must be made to acknowledge the unswerving commitment of Wendel Ray, Douglas Flemons, and Anne Rambo to the clinical aspects of the project. In addition, I'm thankful to Ron Chenail for his many contributions to helping develop the method of scoring conversation in therapy. Without Ron's enthusiasm, humor, and scholarship, this project would not have been completed. He was always on hand to move the work forward. Other members of the team included my close colleague, Monte Bobele, and our associates, Sharon Boesl, Sam Braudt, Loren Bryant, Paul Douthit, Jerry Gale, Shelley Green, James May, Don McDonald, Judy McDonald, Jeffrey Stormberg, and David Todtman.

For the many ways they have contributed to providing a context for the development of the project, I am most grateful to Connie Steele, John Flynn, Tom McCarver, Skip Nolan, and Bill Madsen.

And finally, I express my sincerest appreciation to my son, Scott, for his patience, understanding, and reverence for play.

Foreword

Improvisation may seem odd and even archaic in a culture that increasingly extolls the virtues of planning and prediction, and tells us we could forsee the course of events in such detail that we could control their future outcomes as if they had already happened, or as if past and future were one and the same. This desire to have power over time, and all that time signifies -- creation, change, motion, metamorphosis, decay, and death -- is one of the great themes in the stories told by many cultures, but few cultures have so completely succumbed to that lust for power as has ours in the West, where our dream of total control over nature has nearly eliminated the idea of nature altogether. The end of nature, however, signifies no final triumph of culture, for without nature there can be no culture. The two so imply one another that we can no more conceive of them separately than we can imagine a world where light illuminates no darkness. For us, nature/culture exists only as a simulacrum in the form of an ideology of the technology of control, in which the distinction between nature and culture, and everything that distinction symbolizes, is an illusion created by technology itself. The instruments of control create not only themselves, but simultaneously bring into being what they are intended to control, and these objects of control create the demand for more technology. The reciprocity of dominator/dominated creates a surplus that ever exceeds the instruments of its production. The first paradox of the technology of power is that as control becomes more and more total, what it controls becomes more uncontrollable. The second paradox of power is that as control becomes more and more total, control itself becomes more uncontrollable.

These paradoxes make the opening into another world, the dark twin of the world of unbridled power, where we live in a time symbiotic, synchronous, and

parallel to the time of the simulacrum. It is the everyday, commonplace, baling-wire world of the unforseen, where coping, making-do, cobbling-together, good-enough-for-now, patched-up, hand-me-down, and left-over are the means. It enables the world of technology even as it is necessarily produced by it, and even as it is constantly colonized by it. There is no dialectical overcoming of these two worlds, no third world transcends and resolves their opposition/symbiosis. They continue, endlessly producing and re-producing one another.

As the technology of mind-control has matured through the instrumentalities of writing, print, computation, and all forms of visual telegraphy, it has simultaneously engendered weed-like excesses that are both resistances to control and the sources out of which new forms of control will grow. Conversation, talk, speech, presentation, performance, dialogue, and rhetoric are some of the names for these excesses. All evoke time, the unforseen, and improvisation.

Improvise *(in-pro-videre)*, the un-for-seen and unprovided-for is the negation of foresight, of planned-for, of doing provided for by knowing, and of the control of the past over the present and future. Doing, unguided by "how-to," and uninformed by "knowing" -- those other names for the past, the already seen -- makes the opening for an art that is neither a craft nor a technology capable of being mastered. No mystagoguery of mastery encumbers the improvident being-now, and no history in-forms it.

Improvisation demystifies the mysteries that make the excuses for a profession and deconstructs the myths that legitimate therapy as a kind of knowledge, as theory-informed practice, the application of principles, rules, and procedures mastered through training, apprenticeship, and initiation that justify the therapist as a licenseable owner of saleable knowledge. *Improvisational Therapy* is a self-help book for therapists, inviting them to create individual styles of practice that grow out of their own ways of being and

encouraging them to avoid the easy tricks, the unthinking rule-following, the imitation-of-the-master, the ready-made recipes of cults and charismatics, the lust for power.

Knowing that it is hard to cast off these armors of the ready, Keeney likens therapy to a performing art, where the score or script comes into play after the performance rather than before, and where "practice" does not enable "doing" by means of efficient repetition, but by a kind of inefficiency, a being-unready that prepares beforehand only by making ready to respond in tune, tempo, and theme in order to per-form without being in-formed. A therapeutic encounter thus becomes a conversation in which therapist and client respond to one another without benefit of a script or even of a narrative. The therapist does not control or guide the conversation into appropriate plots of pathology or along proper story lines of sickness, but lets it seek its own ways along multiple paths and through many openings. The therapist is not the "master of talk," the "overlord of the word" managing the discourse and dictating its final meaning. The therapist does not stand outside of the circle of participants, pronouncing the "last word" to another audience. In a conversation, everyone has equal rights to the role of distanced outsider. In its emphasis on conversation and performance, Keeney's *Improvisational Therapy* diminishes the therapist's authority, limits *his* power over the client, and defeats the kind of mind-control that has characterized even the best-intentioned forms of psychotherapy. *Improvisational Therapy* is radical --and much needed-- therapy for psychotherapy.

STEPHEN A. TYLER
Professor of Anthropology and Linguistics
Rice University

MARTHA G. TYLER
Linguist and Practicing Psychotherapist
Houston, TX

Chapter One

INTRODUCTION TO

IMPROVISATIONAL THERAPY

Imagine psychotherapy being contextualized in an academy of performing arts as a discipline comfortably related to theatre, music, dance, and the rhetorical arts. In this setting, therapists would speak of their craft as professional conversation, strategic rhetoric, or even as a genre of interactional theatre. The training of a therapist would focus on developing communicational artistry. Opportunities would be offered that provide practice in encountering the client's rhetorical challenges and surprises. The therapist, like an improvisational actor, would strive to be ready to respond resourcefully to any possible situation.

Therapy as art underscores the therapist's performance. Given the unpredictable nature of a client's communication, the therapist's participation in the theatrics of a session becomes an invitation to improvise. In other words, since the therapist never knows exactly what the client will say at any given moment, he or she cannot rely exclusively upon previously designed lines, patter, or scripts. Although some orientations to therapy attempt to shape both the client and therapist into a predetermined form of conversation and story, every particular utterance in a session offers a unique opportunity for improvisation, invention, innovation, or more simply, change.

The most dramatic shift imaginable in the field of psychotherapy is to free it from the tight embrace of medicalism and scientism and connect it to the creative wellsprings of the arts. The chapters that follow set forth examples of psychotherapy practiced in this spirit.

Becoming an artist involves moving away from impersonating others and developing one's own improvisational style. An artist fully utilizes his or her personal resources and limitations to create a unique style that is an aesthetic portrait of self-in-context. If the therapist loves telling stories, one would expect the therapeutic style of a raconteur. Therapists who have a natural engineering mindset might emphasize diagnosing recursive patterns of interactional sequences within which are embedded so-called "problem" behaviors. Another therapist with a gift for being vulgar and profane might develop a genre of therapy others would experience as "provocative."

Improvisation invites "being creative with what you know" or "doing your own thing" as jazz pianist Marian McPartland describes (in Lyons, p. 174). Whether this involves embellishing a particular theme, or altering whole structures, orders, rhythms, melodies, meanings, and lines of action, improvisation is a way of indicating the many ways a therapist participates in the process of creative change.[1]

With this redefinition of therapist-as-improvisational artist, many traditional pathways in the field of psychotherapy become less interesting. Fewer therapists would debate about the "best" school of therapy. Who would take seriously any attempt to measure the outcomes of listening to different jazz musicians, say Stan Getz versus Charlie Parker? Who would attempt to ask which genre of music, literature, or

[1]The legendary jazz pianist, Art Tatum, demonstrated an amazing artistry of improvisation with his "penchant for trying to make bad pianos sound good" (Taylor, p. 168). Finding a way to exploit the "bad piano's" limitations (as well as anything on the piano that sounded "good"), he could incorporate the instrument itself into the improvisation. Perhaps teachers of therapy who complain about a "poor trainee" should rethink how such a trainee provides an opportunity to broaden the improvisational strategies of the teacher.

dance is the "best?" Are these the most meaningful questions?

Schools, models, and orientations to psychotherapy can be understood as portraits, exteriorizations, or rationales for the people who invented them. They are simply examples of different people's ways of evolving a style that fully utilizes their own unique resources in a particular context.

With this understanding, Chapter Two, "Improvisational Therapeutic Strategies," begins by presenting a wide variety of novel ways to organize therapeutic conduct. Therapists are encouraged to approach each strategy as a general theme that can be drawn upon in the improvisation of therapeutic conversation.

Chapter Three, "A Brief Approach to Intervention Design," presents a very parsimonious way of creating interventions. Designed in this way, interventions are intended to evoke the creativity and improvisational contributions of both therapists and clients.

Chapter Four, "A Method of Scoring Conversation in Therapy," introduces a method which enables therapists to relate to their conversations with clients in a way similar to that of a musician using musical notation to relate to music (and a dancer using dance notation to relate to choreograpy, and so on). In addition to helping organize conversations with clients, this method of scoring paves the way for conveniently notating and relating in a practical way to the styles and genres of different therapists.

Also in Chapter Four, the usefulness of scoring as a method of case presentation is demonstrated. In music, for example, a collection of the brief outlines of different songs is called a "fake book." It enables the musician to have ready access to an enormous amount of music. Similarly, this chapter shows how clinical case scores can be created by therapists, providing them with immediate access to the broad outlines of an entire collection of therapeutic work.

Chapter Five, "Therapeutic Moves: Creating Openings, Connections, and Disconnnections," presents illustrations of a variety of conversational moves that therapists can use to make a shift or difference in their conversation with clients. These moves are readily identified with what therapists typically call "therapeutic technique." With this orientation, technique concerns the creative handling of language that helps move conversation toward the experience of being "therapeutic." These therapeutic moves are somewhat analogous to the chord progressions and technical embellishments jazz musicians use to enrich and enliven their music.

Chapter Six, "Hilda's Gallery: Composition of a Clinical Case," demonstrates how the notational system presented in Chapters Four and Five can be used to organize and compose a strategy for an ongoing case. This clinical case, a systemic treatment of an individual spanning multiple sessions, was supervised by the author in a training setting.

Chapter Seven, "Creating One's Own Clinical Style," presents a way for therapists to critically examine and evaluate personal resources and limitations facilitating the move toward developing their own unique improvisational style.

One intention of this book is to challenge therapists to seriously consider doing whatever they want. The voices of various schools, orientations, and models (family therapy, couples therapy, individual therapy, systemic therapy, gestalt, experiential, NLP, psychoanalysis, structural, humanistic, client-centered, Ericksonian, Milan, cognitive, strategic therapy, etc.) will always be as persuasive as they possibly can, arguing that their particular approach is the most effective, appropriate, ethical, and therapeutic for clients. One way of understanding these voices of persuasion is to recognize that they are the speakers' best effort to convince *themselves* that what they do in therapy makes sense. The economics and politics of maintaining particular therapeutic institutions need not be mentioned.

What is a school, orientation, or model of therapy and where did it come from? In the beginning, someone or a small group experienced an "originating insight." An idea of how to make sense of talking with others in a therapeutic context was born. With this original charismatic experience, the originator(s) creatively developed further deviations and implications until a well-formed web of understanding (and persuasion) was established. At this stage, students and followers demanded that the originating insight and the accompanying hermeneutic web be spelled out and written down. Texts and texts about how to interpret texts emerged, and a second generation of therapists began arguing about the originator's original meanings and intentions. Following the multiplication of texts and prescriptions for rituals, institutions emerged. It is here that part-time therapists continue to jockey for positions in the hierarchy of a bureaucracy whose primary purpose is to maintain and escalate the proliferation of bureaucratic structures.

The improvisational therapist cares less about loyalty to texts and institutions and more about experiencing, utilizing, and sharing the creative inventions of one's own imagination. This book encourages the therapist to listen to his or her own voice and to draw upon his or her own resources and limitations.

Never to be forgotten is the fact that teachers are often the most dangerous obstacles to learning. Texts obscure the originating insight that led to the web, story, system, or context that attempts to present, explain, and persuade. And most importantly, contexts are constructed to *con*tain a *text* for someone's particular political intentions.

With these understandings, therapists are advised to be mindful of the following:

1. Cultivate a healthy irreverence for all teachers and teachings (including this one).

2. Do what you want with any therapeutic model, school, or orientation -- utilize it, ignore it, kick it, invert it, reverse it, distort it, misunderstand it, play with it.

3. Be cautious when therapy doesn't feel like play, never forgetting that play is serious work.

4. Experience psychotherapy as theatre: when it's boring, change anything -- the script, the actors, the director, the audience.

5. Theory is critical for evolving clinical work: with every new understanding, you become a different person--the person you previously were *plus* the new understanding. This new you cannot necessarily perform what worked for the previous you. This means you must learn to do something different. Doing something different leads to a new experience which in turn can be subjected to understanding.

A final warning: There is a perverted occurrence in the field of psychotherapy -- the anointing of a privileged class of experts who go by the name, "master therapist." I encourage all therapists to become clinically concerned with anyone who wears such a badge of one-upsmanship. To be regarded as a master is the first step toward *un*becoming a resourceful and creative therapist.

Consider the consequences when others believe you are a "master": You will find that it no longer matters what you say. Everything uttered will be contextualized as the voice of a master. A casual handshake will be taken as a trance induction. Personal stories about raising your children will be interpreted as cleverly crafted embedded messages uniquely designed to change someone else's problem. A belch becomes a brilliant intervention. The snoring in a nap becomes the voice of therapeutic wisdom. And the free associative blabbering of absolute nonsense is carefully recorded as

the therapeutic discourse of the future. Beware the lies of fame.

Avoid the political posturings of "mastery" and return to embracing and cultivating a beginner's mind. Maintain and respect ignorance. Speak to hear the surprise from your own voice.

IMPROVISATIONAL

THERAPEUTIC STRATEGIES

In jazz performance, a musician uses a song or tune as a basic structure for improvising. For an improvisational therapist, particular schools, orientations, and models are *re-cognized* as though they were simply different tunes or songs. Asking an improvisational therapist whether he or she is exclusively an MRI problem-solving therapist would be like asking a jazz musician if he or she only plays the song, "I Left My Heart in San Francisco." The energy and creativity it would take to keep one's imagination alive under the constraint of playing the same song time and time again is unimaginable. How long can therapists sustain a commitment to one model without feeling a loss of enthusiasm and zeal?

When therapies are viewed as songs, the therapist's creativity is more easily awakened. One can choose to play the song exactly as it is scored or one is free to improvise. With this shift in contextualizing therapy, a new profession is launched -- the equivalent of a songwriter for psychotherapy. Consider how odd it is that inventors of a particular school of psychotherapy typically write only one song and spend the rest of their lives persuading others to play it. Professional songwriters, on the other hand, devote their careers to writing as many different songs as there are situations moving them to compose.

This chapter can be viewed as a songbook of therapies. It presents a variety of different strategies, each of which can be regarded as a capsule presentation of an entirely different school, orientation, or model of

therapy which, theoretically, someone else could spend an entire career developing and promoting. From the perspective of the improvisational therapist, however, what follows are simply new songs that may be played in whatever way the therapist finds appropriate and useful to a particular therapeutic context.

The MRI Reversal Technique

The therapeutic model set forth by Watzlawick, Weakland, and Fisch (1974), psychotherapists at the Mental Research Institute (MRI), is one of the most familiar approaches to brief problem solving therapy. It proposes that problems are maintained and exacerbated by inappropriate attempted solutions. In other words, the "real problem" is the solution. Accordingly, changing the class of solution, which may include efforts to refrain from solving the problem directly, provides the avenue to desirable change.

The MRI Reversal Technique is a therapeutic strategy that goes in the opposite direction. Therapy begins in the same way -- eliciting information about the presenting problem and previous attempts to solve it. The next step, however, introduces a reversal of the MRI therapeutic strategy. A therapist can do this as follows:

Let me explain what I believe will be an important way of working with you. At this point, we're clear in defining the problem. You've also indicated a history of experiencing one failure after another in your efforts to solve it. This history of experienced failures concerns me. With every failure, you set up a situation wherein you have less faith and confidence in your ability to create an effective solution. With this loss of confidence, whether you're consciously aware of it or not, the creative part of your mind becomes more reluctant to try again. Clearly, the solution to your problem can come from you. What we must do is get your

creative mind to have more confidence in its ability to come up with the appropriate solution.

There is a way. Each attempted solution you previously tried is, in fact, an appropriate, creative solution for some *other* problem. We need to think about what problems would be solved by the previous solutions you've tried. If you can experience these solutions as being successful in solving other problems, your creative mind will become confident again. Then we'll be halfway home. You see, every solution must find the problem that fits it until you can move on to another solution to solve a different problem.

At this point, the therapist works with the client in discussing problems that would fit the previously attempted solutions. Enactments can take place in the session or tasks can be given in which the client pretends to have the problem that fits the solution. The client is discouraged from trying to solve the presenting problem until all previous attempted solutions have been matched with problems that fit them. Any effort to solve the presenting problem that results in failure is, in turn, subjected to the same procedure. Namely, a problem must be found to fit it.

Experiencing a Well-Formed Problem

This therapeutic strategy begins by eliciting communication that defines the client's presenting problem. The initial therapeutic conversation focuses strictly upon descriptions of the problem. No inquiry is made about attempted solutions. The next stage shifts to explaining the therapeutic approach:

I'm concerned that you don't have a "well-formed problem." By this I mean you have what is sort of a problem, maybe one-half of a problem, or even 80% of a problem. If your problem were perfectly congruent, complete and well-formed, then

the solutions you have tried would be effective. This means we need to look very closely to determine how developed your problem is. If it's not well-formed, as I suspect, then we need to work to evolve it toward being a 100% pure problem that completely confirms and satisfies the criteria and descriptions specified in the professional literature. When we get to that point, your solutions should have no problem doing their job.

Following this discussion, the therapist may consult textbooks, dictionaries, and case descriptions enabling a contrast or difference to emerge between the client's description of the problem and that of the professional literature. From there, interventions could be developed that prescribe behavior designed to make the problem 100% well-formed.

Curiosity Therapy

Curiosity therapy begins with the first moment of the beginning session when the therapist tells the client:

Before beginning our work together, I want to explain how I work. What we won't do is spend any time talking about what you experience as a difficulty or problem. Why? I have found that most people who come see a therapist are already drowning in too much thinking, feeling, and talking about their problem. When they wake up in the morning, they immediately begin thinking about the problem, or imagine themselves in a conversation with someone else in which they are talking about the problem. During the course of the day, they repeatedly catch themselves thinking about the problem, considering whether to tell colleagues, friends, or family members. If not thinking intently about the problem, it is typically just in the back of the mind. Before going to sleep, they think about the

problem. Whether they know it or not, they probably dream about the problem.

Now, how can we make sense of this? Do you remember when you were once a student and had a chance to see how a crystal can be grown? The procedure involves taking a piece of thread and tying a tiny seed crystal on it. Then you fill a test tube or container with a supersaturated solution so that when you dangle the seed in it, a crystal begins growing. It will grow and grow, taking the solid matter out of the solution until the whole container is nearly filled with the crystal.

A problem has a lot in common with a seed crystal. When placed in the supersaturated space of your mind, it will grow and grow, until all your experiential space has become filled with the crystal, that is, the problem. This is what is happening to you. When your mind is filled with the problem, one can accurately say that *you are the problem or the problem has become you.*

The worst thing I could do is provide more supersaturated solution to aid your crystal in getting any larger. You're probably already drowning in and overwhelmed by this problem crystal right now. So, no more talk in this therapy container about problems.

I want to introduce you to another seed crystal that will distract your mind from the problem. For this crystal to grow and successfully distract you, it must arouse your curiosity.

If you're ready to begin, what we'll do now is try a "curiosity assessment." I can give you a list of words that may signal something you're curious about, such as The Book of Revelations, *The I Ching,* Carlos Castaneda, science, psychoanalysis, unconscious process, and so forth. You could stop me when you hear a "buzzword" about something that really fires your imagination and curiosity. Or you could, right this very moment, say everything that comes to your mind that you might be curious

about. Then we can look back and choose which of these most activates your curiosity.

After the client has determined the subject of his or her greatest curiosity, the therapist designs an intervention that simply aims to maintain the therapeutic theme of curiosity. Subsequent followup and therapeutic conversation would focus on assessing curiosity strength, the size of the curiosity crystal, distraction effects, and so forth. Problems are never discussed, with the rationale that building a crystal of distraction is the most effective solution.

Supervising Client Discourse

Most "live supervision" of clinical work involves a supervisor behind a one-way mirror directing the discourse of a trainee who is working with a client system. This supervision situation is often the enactment of a mind/body duality: The supervisor minds the trainee's action. In tightly supervised situations, the supervisor is like an engineer who works behind a leaded mirror, arms encased in robotic limbs to handle the radioisotopes in the laboratory. Whatever the particular supervisory structure, the goal is the same: direct the therapist trainee to have the appropriate conduct.

In this strategy, a major shift is implemented. The supervisor says nothing to the therapist, talking instead directly to the clients. The initial rationale given to both clients and therapist follows:

We often think the therapist is the one who needs guidance to say the right thing to clients. Actually, it's a bit more complex. Clients, too, must act upon the therapist to get him or her to say what would be most useful to them.

This strategy assists clients in saying the sorts of things that may help trigger the therapist to be therapeutic. The therapist is encouraged to be

himself or herself and to wait for his or her imagination to be awakened by the clients. My job, as a supervisor, is to help clients wake up the therapist.

With this rationale, supervisors can do all the things with clients that were formerly done with therapist trainees. Phone calls to clients can take place, suggesting certain questions. Should a client become confused, he or she could step out of the room and go behind the mirror for a consultation.

Supervisors can suggest that clients ask questions such as, "I heard about another therapist who saw someone like me and suggested the opposite of what you just said. What do you think of that?" Or a client might be prompted to ask, "Do you think your colleagues behind the mirror are bored with what we're saying?" Other questions supervisors can suggest to clients include:

"If I were to say something now to make you look like a master therapist, what might it be?"

"What would I have to say for you to think I'm a hopeless case?"

"Is my problem interesting enough to be written about in a journal?"

"Make up three interventions you think I would never agree to do."

"Do you think there's someone else involved in the situation that I haven't told you about, like my grandmother or grandfather?"

"Do you think I'm capable of making one small change this week?"

"Who in the family do you think I believe is closer to Father?"

"If I told you something really bizarre, do you think you would want to keep me in therapy any longer?"

"Who do you think is the best therapist in the world? What do you think he or she would say to me right now?"

"If you knew I would follow exactly what you tell me to do, what assignment would you give me for next week?"

For the supervisor, a decision to intervene is dictated solely by when the discourse is experienced as emotionally flat and boring. When the discourse is experienced as alive (one can't define it, but one can recognize it), the supervisor stays out of the way. Thus, a contextual structure is built in which the supervisor helps clients awaken the creativity and imagination of the therapist, paving the way for effective therapy to take place.

Cybernetic Treasure Hunt

Treasure hunts involve moving from one point to another until you get to a treasure at the end. A "linear" treasure hunt, the kind we're all familiar with, is preplanned with the sequence constructed in an unalterable way. That is, the hunt goes from A to B to C to D to the treasure. A "cybernetic" treasure hunt involves a more improvisational plan in which each step is a consequence of the outcome of the previous step. Feedback determines the direction of the hunt.

As a context for working with a couple or group of couples, a cybernetic treasure hunt consists of many sessions packed into a full-day marathon. It begins with an initial interview followed by assigning a therapeutic task that involves doing something in the environment where one lives. For example, the couple might be directed to visit a local landmark and have an argument about the historical meaning of the site. Each task is designed to find clues suggesting the next step. The couple reports back, and based on these clues another task is assigned, sending them somewhere else.

This procedure continues until the couple begins believing they see a desirable outcome. At this point, the therapist moves toward a sense of completion by designing a final task which the couple can experience as a treasure marking the end of the hunt.

Beginning at the End

This therapeutic strategy bypasses addressing any understanding of the client's situation. Therapy begins at the end, with an intervention. The first intervention is selected entirely at random, with the therapist providing the rationale in an introductory explanation:

> I want you to imagine that I have an *Encyclopedia of Therapeutic Interventions*. This encyclopedia lists every successful intervention used by every therapist who ever practiced in the history of psychotherapy. If there is anything in the world that will work for you, it will be in this encyclopedia. Our job is to find it.
> What you think you understand about your situation may not necessarily be useful. After all, it hasn't helped you so far. Therefore, we will begin by opening the encyclopedia and giving you the first intervention we come upon. I simply ask that you try to do it to the best of your abilities. Next time we meet we'll see whether the intervention was on target, off target, or somewhere in between. What was it we used to say as kids -- "Are we getting cold, warm, or hot?"

The next session begins with an evaluation of the outcome. If the intervention was experienced as making no difference, that whole type of intervention will be abandoned. If the intervention was warm, another one of that type will be assigned. If the intervention was on target, only fine tuning will be necessary.

With this strategy, the outcome of each intervention shapes the design of the subsequent intervention. This simple feedback loop abandons the beginning and middle stages of therapy, beginning and maintaining itself at the end.

Rehearsing the Opposite Problem in the Opposite Partner

This strategy is useful for working with social systems such as couples and families. After eliciting a clear description of the presenting problem and the identified patient, the therapist sets forth a transitional context:

One of the interesting things about social systems such as couples and families, is that sometimes they develop a very unique way of solving problems. It works like this: Without any apparent planning, the person in the family who is most opposite from the identified patient will develop a problem that is the opposite of the original presenting problem of the identified patient. For instance, consider an identified patient who has a low energy level, sleeps a lot of the time, is unmotivated, doesn't do any work, and who others suspect of being "depressed." Subsequently, an opposite person in the family, say the other spouse, may develop the opposite problem -- having too much energy, insomnia, and manic/workaholic behavior. When this takes place, the identified patient sometimes starts improving.

The improvement process can work in different ways. The typical pattern is that once the opposite partner develops the opposite problem, a small improvement in the identified patient will take place. When this small change takes place, the opposite partner increases the intensity of his or her problem by a small amount followed by another positive change taking place with the identified patient. Again, the opposite partner steps up his or her

opposite problem. In this way a pattern is established in which the opposite partner keeps the situation balanced, compensating for the original presenting problem by intensifying the opposite problem.

With this therapeutic context, a strategy can be designed that enables the therapist to work with the opposite partner as a means of helping the identified patient. The opposite partner is encouraged to pretend to have the opposite problem. The therapist points out that regardless of whether the opposite partner really has the opposite problem, the strategy works. Should any relapse occur in the identified patient, the participation of the opposite partner is examined and addressed.

Teaching Secret Communication

There are times when clients believe they should tell a significant other (parent, spouse, friend, etc.) about a personal secret, yet at the same time they know that telling it would hurt the other person and damage the relationship. The secret can be about anything. Content is less important than the belief that it would be a dangerous shock to the significant other.

Sometimes the client's problem is the opposite -- an inability to refrain from telling others what should be kept secret. Knowing they shouldn't say certain things to others isn't enough to help them overcome the temptation to do so.

The strategy of teaching secret communication can be applied to both situations. Following a general conversation about keeping (or not keeping) secrets, an account about another case may be given as an introduction to this strategy:

There is a way to tell someone what you wish you could tell them and not risk any shock or harm to your relationship. It works like this: Think of what you want to tell them. For instance, in one case, a

middle-aged woman wanted to tell her parents that she had an abortion as an adolescent. She was afraid of the emotional shock this might cause her parents, who were now retired. At the same time, she wanted to "get this off her chest" so she wouldn't be haunted by it all the time.

The therapist instructed her to think of another situation in her childhood in which she had given away something or had thought of giving away something and kept it a secret. The therapist asked if she had ever thought about giving one of her dolls to someone else. She said she had done this once and never told anyone.

The woman was instructed to tell her parents that something had been bothering her for years -- a secret she'd never shared with them. Furthermore, she was to warn them that although they may not consider it a big deal, telling it to them was very important to her. She was told to ask her parents not to laugh, but simply to listen and realize no matter how silly it may seem to them, it is serious to her.

She was instructed to tell her parents about the time she gave away her doll, thinking and feeling all the while that she was really telling them about the abortion. The story about the doll was simply a secret code for telling them about the other event. The therapist pointed out that the effectiveness of this task would be determined entirely by the extent to which she felt that she was really telling the secret. Under no circumstances was she to reveal the secret. She was to speak only through the secret code.

Using this method, the woman was finally able to put her dilemma to rest -- communicating a long-held secret to her parents without hurting them or damaging her relationship with them.

As was mentioned, secret communication techniques can be applied to the opposite situation. The author was a consultant for such a case in which the client was sent to the clinic by his company. He had

been transferred to many cities due to complaints of "sexual harrassment." Approaching women employees, he would use very explicit sexual language, expressing his erotic attraction to them and his desire for sexual relations. The company never fired him, choosing instead to transfer him to different locations. Furthermore, he had been promoted to a managerial position.

Therapy began by pointing out that he was obviously a master communicator and talented employee. Why else would the company be so invested in keeping and promoting him? Our hunch, we said, was that his success in making things happen in his work had elevated his confidence to such a point that he had become "cocky" about his abilities. He immediately agreed.

Furthermore, it was pointed out, his cockiness had led him to becoming overconfident and stupid in the way he talked to women. He had become so skilled at getting what he wanted in business by being straightforward that we guessed he thought the same approach would work with women. This, we argued, was stupid. He agreed.

We proposed that he learn a secret way of communicating. Instead of saying to a woman, "I would love to see you unclothed," we suggested approaching her desk, picking up a book, and innocently asking without any sexual overtones, "Could I take off the cover and check the binding?" While doing this, he was to imagine he was asking the forbidden question. In this way, he could safely and secretly express himself without taking any stupid risks.

Therapy proceeded by role playing and practicing this secret communication. No further complaints were made by others. The company was ecstatic about the improvement in one of their most promising executives, and the man was named "Employee of the Year."

Recreating the First Session

In this strategy, the therapist conducts the first session in any way he or she chooses. What is critical is for this session to be videotaped. The second session begins with the following explanation:

> Today we're going to *recreate* our last session. This is a technique that has brought about amazing results for clients, and no understanding of why it works is necessary in order for it to be effective. Here's how we'll begin: First we will arrange ourselves in the room as we were last time we met and I will turn on the videotape. Each time we hear a small segment of dialogue, we'll stop the tape and try to say exactly the same thing in the same way. This will help us recreate the first session.

At this point, the session begins. The entire tape can be used or the therapist can choose to work with excerpts. Whenever the client repeats a statement from the first session that is about an understanding or definition of the problem situation, the therapist stops the tape and asks, "Do you feel the same way about this statement as you did last week? Is this exactly how you would describe it today?"

As soon as the client communicates a difference between the first session and their present experience, the therapist immediately utilizes this difference as an opening to discuss the theme of change, pointing out that something must have changed to create this different understanding, description or definition. This is explored until sufficient talk about change is evoked. Then it's back to the tape, recreating the first session until another difference is revealed and more themes of change established.

As this general theme of change emerges, the therapist is able to build up a new context, shifting therapy away from handling a situation that won't change to handling a changing situation.

The Batter's Box

Most professions involving live performance have very explicit rules, rituals, and procedures for getting into the "right state of mind" prior to the performative act. These protocols for creating readiness are well known in baseball, where the player's entrance into the batter's box is marked by an elaborate array of ritualistic behavior, including wiggling one's hips, digging one foot into the ground, looking in different directions, uttering superstitious phrases, and so forth. The ritual of getting ready is among the most valued habits batters acquire in their efforts to be the best hitter they possibly can.

Little attention has been given to establishing a batter's box for therapists, where rituals would help prepare the therapist for a client's rhetorical pitches. This strategy prescribes a focus on getting the therapist ready. After stepping out of the box, the therapist, like the baseball hitter, can do only what comes naturally. Purposeful direction is limited to the procedures for getting ready.

Batter's boxes for therapy could include many forms of ritual. Some suggestions follow:

-Write the client's name on a piece of paper in heavy letters and place this paper under the therapist's chair cushion.

-Write the client's name as it would be spelled backwards. Say this backwards name three times before seeing the client.

-Get out a baseball bat and make up a ritual you repeat before each client enters your office. Mark the area where you sit as a batter's box. Think about whether the next client needs you to bunt, get an RBI, go for a homerun, sacrifice fly, and so forth.

-Purchase a book of superstitions. Before seeing each client, read one superstition and reflect upon how this would influence your therapy if you believed it.

-Find tiny photographs of the historically great psychotherapists you admire most (Freud, Jung, Erickson, Whitaker, and so on). Paste these photographs in a neat row on a piece of cardboard. Paste your photograph next to these therapists. Hide this "psychotherapy hall of fame" where no one can find it and you can't easily get to it. Before each session, imagine the hall of fame as a page in an introductory psychotherapy book of the future.

A BRIEF APPROACH

TO INTERVENTION DESIGN

Imagine beginning each new therapy case with the following directive to the client:

Without explaining your situation, give me several different words that best convey what you believe are the most relevant clues for creating the outcome you desire.

Assuming the client could provide these clues and the therapist were to use them in his or her speech, we can at least say that the client's language is being addressed. More importantly, the therapist would be using metaphors that connect directly to the understandings, beliefs, and ideas associated with the client's situation. Furthermore, with access to these basic clues or metaphors, the client's understanding could be addressed and utilized regardless of whether that understanding is understood by the therapist.

Creating a list of clues about a case is not limited to the direct method just described. Another way is for the therapist to listen to the client's discourse, noting which words are articulated in a markedly different way - a change in volume, tonality, pitch, or duration. Writing these words down as the client presents them results in a list of clues. Or, the therapist could take a break from the session and based upon the conversation, he or she could choose several words that are most representative of the case. Still another way is for an observer or team of observers to keep track of the relevant clues.

Regardless of how it is created, this list of clues becomes a set of *resource frames*. Resource frames are the basic ingredients or building blocks that can be linked together to create an intervention. Consider, for instance, these resource frames or clues about a case:

pencil
book
interfere

As an exercise, construct several interventions that contain these clue words. Do not worry about whether any of them make complete sense. Instead, allow your imagination to combine the words into creative assignments. Two examples follow:

Place a *pencil* in your spouse's favorite *book* and plan a way of *interfering* with anyone's effort to open it.

Take a *pencil* and write the word *"interfere"* in the middle of a *book* that is important to you.

Some critics may question how interventions designed in this way could possibly be relevant and helpful to clients. Recall, however, that the ingredients of these interventions are derived from the therapist's best efforts to distill all of the therapeutic conversation into the most basic themes, root metaphors, representative indices, or primary meanings that the client offers. The mere mention of these terms will resonate harmoniously with the world view and understandings of the client. The important difference is the directive to *act* in new ways as a consequence of new connections of these clue words and their associated meanings.

What further assurance does the therapist have that the interventions will be appropriate to a specific client? It is one thing to take several words out of context and connect them into directives, tasks, or

statements of understanding. It is an entirely different matter to weave together the most meaningful words one derives from the context of a conversation in which one was a major participant. Although the therapist consciously focuses on combining particular words, he or she does so as one who is totally immersed in the whole context from which the words emerged and into which the intervention will be delivered. Stated more abstractly, the therapist's conscious attention is anchored upon several principal metaphors, while the therapist's unconscious imagination, fully organized by the whole fabric of the relevant context, is the shaper and designer of the specific intervention.

In essence, this method of creating interventions involves two skills: First, the skill of extracting the most meaningful resource frames from a therapeutic conversation; and secondly, the skill of combining these resource frames into interventions. Therapists who set aside time every day to practice different ways of putting together resource frames will develop the kind of skill that enables them to seize what is most resourceful to work with in each therapeutic situation. Practicing the art of wordsmithing with respect to combining words into imaginative prescriptions of action and understanding offers a client creative pathways toward an effective therapeutic outcome.

Interventions, Rationales, and Theory

In addition to being the ingredients for weaving inverventions, resource frames also provide the key ingredients for building an explanation for the client. Furthermore, transforming these same resource frames into a more abstract explanation or rationale enables the therapist to build a theory for professional colleagues. The example that follows demonstrates how simple resource frames can be used to build therapeutic interventions, rationales for the client, and theory for the therapist.

Suppose a client comes to therapy and in the course of conversation the therapist underscores the following statements:

"We're fit to be *tied*."
"We're really in a *knot*."
"We don't know whether to *break* up."
"Can we *tie* things back together?"
"I didn't *notice* when things started to fall apart."

The resource frames for these statements include "tie," "knot," "break," and "notice." With these frames, a therapist can move toward setting the groundwork for an explanation or rationale for the intervention that will follow. The therapist's conversation could include statements such as, "Have you *noticed* whether you're really un*tying* the *knot* and *breaking up* or whether you're trying to *tie* a more satisfying *knot* that will keep things together?" With this foundation in place, the intervention is given to the client:

Tie a string from the back of your car to some part of your house. Slowly back your car away, *noticing* if you can detect the moment the string *breaks*. Can you feel it break? Can you hear it? Can you see it? Tie the string together again and repeat. Try various sizes, lengths and *knots* of string.

The task of building theory for professional colleagues begins by transforming the basic resource frames into more abstract metaphors suitable for theoretical discourse. Note these possible transformations of resource frames into theoretical abstractions:

Tie: assimilation; integration; fusion
Notice : awareness; consciousness; perceptual threshold
Break: differentiation; individuation; schizmogenesis

Prose such as this might be used in an academic paper to explain the intervention:

"The couple's *perceptual threshold* regarding *conscious awareness* of their struggle to strike an *integrated* relationship between the processes of *differentiation* and *assimilation* were addressed so as to avoid either excessive *fusion* or *schizmogenesis*, both at the cost of healthy *individuation*."

Interventions

The remainder of this chapter consists of a variety of interventions designed from resource frames presented in therapeutic conversations. Each example will set forth the noteworthy statements in the session, followed by identifying the resource frames, and finally, the intervention is given in its complete form. As an exercise, the reader is invited to practice combining the resource frames into other interventions. In addition, professional theories and explanations of each intervention can be constructed by following the procedure of first transforming the resource frames into more abstract jargon and then weaving these professional metaphors into a theoretical rationale.

Case 1:
Noteworthy Session Lines:
"I always end up doing the *opposite* of what I want. My *problem* probably isn't *meaningful* to anyone else. Am I *lying* to myself?"

Resource Frames:
opposite
problem
meaningful
lie

Intervention:
Choose the book you believe is the most important and *meaningful* book in your life. Immediately after experiencing your *problem*, do the following: With your eyes closed, open the book at random and point your finger to any spot on the page. Open your eyes and write down the sentence or paragraph your finger landed on. Now, in your own words, write down the *opposite* of what the sentence or paragraph means -- something that would really anger the original author. Carry this false message, this *lie,* in your pocket. Every time you find yourself considering doing what you believe you shouldn't, read it aloud.

Case 2:

Noteworthy Session Lines:
"I'm always talking on the *phone* to my friends about my *problem*. Most of them say I should just learn by *correcting* my *mistakes* and move on."

Resource Frames
phone
problem
correcting mistakes

Intervention:
The next time you're tempted to think about your *problem*, immediately open the *phone* book. Randomly select a residential phone number and dial it. When someone answers, ask the following question: "Do you have an opening tomorrow?" Reflect on the response to your inquiry. Does the person say, "No, you have the wrong number", or do they silently hang up? Consider how many ways people have of saying no and *correcting mistakes.*

Case 3:
Noteworthy Session Lines:
"My wife says I have *nothing* to say. She should have married someone *highly technical* and then she would want to be *seen by others*."

Resource Frames:
nothing
highly technical
seen by others

Intervention:
Go to a used book store or library and bring home a *highly technical* scientific or mathematics book. Make sure the title is highly technical and the cover can be easily *seen by others*. Under no circumstances should you open the book. Never look inside it! Take this book with you everywhere. When people ask about it say, "It's really *nothing*." Do not say anything more. If you open the book or if you tell someone too much about why you're carrying it, start over again with a different book until you get through a whole week.

Case 4:
Noteworthy Session Lines:
"My whole life is *unbelievable*. Why can't I *change my life*? Why? Why? Why?"

Resource Frames:
unbelievable
change my life
why

Intervention:
Make up an *unbelievable*, exotic, wild theory about *changing one's life*. Explain it to as many people as you can until you find someone who believes it. Ask them to explain *why* they believe it. Write down their reactions. Keep this paper stored in a secret place.

Case 5:

Noteworthy Session Lines:
"I always give into the *temptation* to *do it:* I *detest* myself and I'm *angry* about that!"

Resource Frames:
temptation
do it
detest
angry

Intervention:
Look through newspapers and magazines, cutting out the photographs of famous people you *detest*. Choose people who you can easily get *angry* about. Paste 13 of these photographs on a large piece of cardboard. In large letters, write on the top of this cardboard, "Go ahead, *do it* again for us.". Store this poster in a closet. When you're struggling with your *temptation*, pull it out and examine it closely.

Case 6:

Noteworthy Session Lines:
"They used to call me a *squirt*. If you knew me, you'd know how I can't *control my impulses*."

Resource Frames:
squirt
controlling impulses

Intervention:
Purchase a *squirt* gun. Fill it with water, seal it in a plastic bag, and carry it with you to a social situation. At an inappropriate but safe time, squirt someone. Before they have a chance to react, tell them you're sorry, but you're working with a therapist who says you need to practice *controlling your impulses*. Say no more. If they ask you why you can't say more, tell them this, too, is part of learning to control your impulses.

Case 7:

Noteworthy Session Lines:
"We can never get the *whole family together* on *important family decisions.* It's even impossible to get everyone's *signature* on a greeting card."

Resource Frames:
whole family
together
important family decisions
signature

Intervention:
Purchase an oversized pen or pencil. Find a large piece of paper and have the *whole family* do the following: Each person must hold the pen or pencil at the same time and *together* sign the family name on the paper. Consider this the family *signature.* Practice writing the family signature several times until it can be done smoothly and naturally. In the future, when an *important family decision* is made, get out the pen or pencil and ritualize the decision by signing the family name.

Case 8:

Noteworthy Session Lines:
"No one in this family ever *pays attention, listens*, or bothers to be *together.* No one can be *heard* in this family."

Resource Frames:
not pay attention
not listen
together
heard

Intervention:
Choose a time when everyone in the family can eat *together.* At this meal everyone must try, to the best of their abilities, to *not listen* and to *not pay attention* to

anyone else. Instead, each family member must concentrate only on what they themselves think and say. After the meal, have a discussion to see if there was anything that was *heard* by everyone in spite of each person's efforts to not hear anyone else.

Case 9:
Noteworthy Session Lines:
"There's total *silence* about what anyone *feels* about being *together*."

Resource Frames:
silence
feels
together

Intervention:
Using a cassette tape recorder, each family member must do the following: Set the tape to record, and then in *silence* imagine saying everything you *feel* about being in your family. Do not say anything aloud. Say these things only in your mind. Each person should record for no longer than ten minutes. After all members have recorded their feelings, gather the family *together* and play the silent tape. Set the volume at a comfortable level as though there were something to hear. Remain silent and listen to what you can't hear.

Case 10:
Noteworthy Session Lines:
"We're like a bunch of *leaves* that keep *breaking apart*. We could find a way to be *joined together* if we weren't so *asleep*."

Resource Frames:
leaves
breaking apart
joined together
asleep

Intervention:
The parents in the family should go into their backyard or to the nearest park and choose a *leaf* for each family member. They should carefully choose leaves that remind them of each individual. Throughout the following day, each family member should carry this special leaf at all times. At the end of the day, the parents should collect all the leaves and put them in a jar to be stored in a place where they will not be disturbed. Once a week the family should get the jar out and look at the leaves. When they are completely dry, brittle, and beginning to *break apart*, the leaves should be crumbled into a powder so they are thoroughly mixed and *joined together*. The parents should sprinkle a tiny amount of this powder into each child's shoe while they are *asleep*. One year later, tell the children what you did but never explain why you did it.

Case 11:
Noteworthy Session Lines:
"If people around here would *say* some *kind words* every once in a while, I might feel a *connection*. As it is, you don't know who *belongs* here."

Resource Frames:
say kind words
connection
belongs

Intervention:
Take the whole family to a park near your home. Choose a tree that everyone feels a *connection* with. Together visit this special tree as often as possible. Pick up any trash around it, touch it, *say kind words* to it. Think and talk about it during the week. When you feel as though this tree *belongs* to the family, take a picture of it. Have an enlargement made of this photograph and hang it in a special place in your home. Consider giving your tree a name.

Case 12:
Noteworthy Session Lines:
"I can't figure out whether I *should change* or whether I *shouldn't change*. Some days I feel I should change. Other days I think I shouldn't. Maybe it should be somewhere in *between*."

Resource Frames:
should change
should not change
between

Intervention:
Write on a sheet of paper the best reason you can think of for why you *should change*. On another sheet of paper write down the best reason you can think of for why you *should not change*. Apply glue to these pages on every letter of every word in each message. Press the pages together face-to-face. Make sure you have a perfect seal *between* the two messages. Keep this combined message for at least a month and mail it to yourself before throwing it away.

Case 13:
Noteworthy Session Lines:
"I know I haven't lost my *marbles!* In spite of *dealing with* my *problems*, I've had some *positive experiences* in my life. I just need to get *recharged*."

Resource Frames:
marbles
dealing with problems
positive experiences
recharged

Intervention:
Purchase the most beautiful *marble* you can find. Carry it with you at all times. From this moment forward, do the following: Every time you find yourself having a positive life experience, squeeze the marble as

hard as you can with each hand. These *positive experiences* can be moments of laughter, hope, or exhilaration; an insight, an inspiration, or a job well done; receiving a compliment, doing something kind for someone else, or an interesting idea you hear about. Whatever you regard as a positive experience, use the occasion to squeeze your marble.

Each time you squeeze that marble, visualize filling it with a positive energy force. With each squeeze and each positive experience, the marble becomes more and more charged.

After charging the marble for one week, use it as a resource for *dealing with problems* the following week. Catch yourself when you are struggling with a difficulty and squeeze your marble, visualizing it giving you positive energy and strength to come up with a solution. Do this for only one week, assuming that the marble's energy needs to be *recharged* the following week.

Go back and forth, week to week, alternately charging and being charged by your marble. After one month, you will be ready to start carrying two marbles so you can always be using one and charging the other.

Case 14:

Noteworthy Session Lines:
"An old teacher once told me that an *idea can change your life*. If I could just get something *under my head,* things might get better."

Resource Frames:
an idea can change your life
under my head

Intervention:
Look through your books and set aside those you believe might have *ideas that could change your life* in the direction you want to change it. Or, go to a bookstore or library and bring home five books whose ideas could change you. Before going to bed, put one

book *under your head*, beneath your pillow, and sleep on it. Change the book every night. Do this for at least one month.

Case 15:
Noteworthy Session Lines:
"Yes, I believe the best things in life are *inexpensive*. I learned that at an early age from a *children's story*. My problem is how to feel *significant* again.

Resource Frames:
inexpensive
children's story
significant

Intervention:
Go to a garage sale and buy the most *inexpensive* item you can find. Take it home and try to make up a *children's story* about this item. Be sure the story portrays it as having a special *significance*. Tell the story to someone and see if they look at your item in a different way.

Case 16:
Noteworthy Session Lines:
"He's always called me an old *rug*. If I could *shake off* all this *worrying*, I'd show everyone a thing or two."

Resource Frames:
rug
shake off
worrying

Intervention:
Purchase a tiny throw *rug* and store it in a closet. At the end of each day, get out your rug, take it to a private place, and stand on it. While standing, do all the *worrying* you need to do about what happened during the day and what may happen to you tomorrow. Try to do all your worrying for the day during this time. When

you're finished, take the rug outside and *shake* it *off* thoroughly, getting rid of all the dust. Return it to your closet and use it again each day.

Case 17:

Noteworthy Session Lines:
"It all comes down to finding *respect*, however *close* or *far* away you have to go to get it. Remember the *Wizard of Oz?* You've got to follow that *yellow* brick road."

Resource Frames:
respect
close
far
Wizard of Oz
yellow

Intervention:
Purchase five copies of the book, *The Wizard of Oz*. Write down the names and addresses of five people you *respect*. On a map, put a small mark indicating where each person lives. With a *yellow* marker, draw a line or imaginary road that connects them all. Mail a copy of *The Wizard of Oz* to one person every other day. Send the first book to the person who lives *closest* to you, the next to the person living closest to the first person, and so on, until the last book is sent to the person living the *farthest* away.

Case 18:

Noteworthy Session Lines:
"If I had some *insight or understanding*, I might find some *peace with my situation*. You're right about where I'm looking for it. It will probably come from *helping someone.*"

Resource Frames:
insight or understanding
peace with my situation
helping someone

Intervention:

Imagine you are stranded on a desert island and decided you did not want to be rescued. Suppose you had an amazing *insight or understanding* about life, giving you a complete sense of *peace with your situation* on the island. You want to share this insight with the world, so you are sending a message-in-a-bottle. With this in mind, compose a message no longer than one-half page. Put it in a real bottle. Take this bottle to a library in your city and leave it on the shelf where self-help psychology books are kept. In the weeks to come, try to imagine the ways your message in the bottle might be *helping someone* .

Chapter Four

A METHOD OF SCORING

CONVERSATION IN THERAPY

*"The way out is through the door. Why is it that
no one will use this method?"*
-Confucius

Pretend, for a moment, you are a professional
screenwriter working in Hollywood and the head of a
major motion picture company calls and asks you to
write the screenplay for a new movie. The producer
gives you this beginning story line and you are to work
out the rest: A mother and father are awakened at 2:30
a.m. by the police, who inform them that their adolescent
son has been arrested for disturbing the peace and
stealing the high school baseball field's "home plate."
That's all you have to work with. You must
finish the story. However, there are two conditions:
First, it must conform to the genre of literature called
"realism." That is, it must be a story that people will
believe could really happen. Secondly, the ending
should engender in the audience a sense of completion --
a resolution in which the main characters are better off
than when the story began.
Your first step is to construct an outline,
blueprint, or diagram for the story comprised of a
beginning, middle, and end, which professional
screenwriters refer to as Act I, II, and III, respectively
(Syd Field, 1982). The typical form of a screenplay
follows:

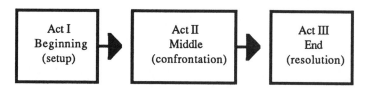

Like screenwriting, psychotherapy can be examined as the construction of stories that also have a beginning, middle, and end. Act I or the beginning of a psychotherapy case is the first session in which the client introduces the presenting situation. The therapist and client continue by moving through transitional or middle acts until they arrive at a satisfactory resolution.

The major difference between the screenwriter and the therapist is that in psychotherapy the story lines created include the contribution of all participants interacting in real time. That is, the therapeutic lines are improvised -- composed as one moves along in the flow of the conversation.

With this in mind, what follows is a way of outlining, notating, or scoring therapeutic conversation that will provide the therapist with a practical method for keeping track of the story in which he or she is participating.

Therapeutic Frames and Galleries

This method of scoring conversation in therapy is analagous to the notational methods used by musicians, choreographers, and screenwriters to give them immediate visual access to the whole context of a song, dance, or story. Similarly, by scoring therapeutic conversations, the therapist can immediately visualize the context of a case without engaging in cumbersome, distracting theoretical or clinical discussions. This method provides an ideal tool for organzing real-time therapeutic participation in an ongoing clinical case, as well as for post hoc analyses of whole sessions.

The fundamental conceptual tool used in creating a score of therapeutic conversation is the familiar notion, *frame*. A *frame* indicates the *contexts* a client and therapist offer each other.[1] If they are engaged in a conversation concerning a presenting problem, such as the troublesome occurrence of the youngest son's asthma attacks, we can say the conversation is taking place within the context or *frame* of "problem definition." Should the therapist and client begin exploring why the asthma takes place, the conversation has shifted to a "problem explanation" *frame*.

Note, however, that these examples are frames of the same class -- they are both "problem" frames. To indicate a class of frames, the notion, *gallery* is introduced. In the above examples, the *gallery* labelled "the problem" contains "problem definition" and "problem explanation" frames. Thus, therapeutic conversation is contextualized by frames and classes of frames called galleries.

With these two notions, *frame* and *gallery,* an aesthetic understanding of psychotherapy is possible. That is, one can experience a psychotherapy session as a walk through an art exhibition. At the beginning of the therapeutic hour, conversation takes place in the *presenting gallery,* where the client typically leads the therapist around a room with frames hanging on the wall. In most cases, these presenting galleries have frames containing impoverished experiences for the client.

The purpose of therapy is to move conversation out of this impoverished presenting gallery and into a *therapeutic gallery* where the client and therapist can experience and utilize frames as a resource. Moving from gallery to gallery requires an *opening* -- an open

[1]Historically, the use of the term "frame" as a name of context was proposed by Gregory Bateson (1972) and has been used by a variety of psychotherapists, communication researchers, literary critics, and in artificial intelligence programming.

door facilitating a smooth transition from one gallery to another.

The conversational path from the impoverished *presenting gallery* to a resourceful *therapeutic gallery* usually takes the participants through transitional, *bridging galleries*. The basic flow of conversation in psychotherapy is scored as follows:

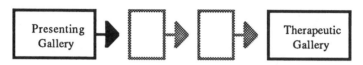

Bridging Galleries

With this basic method of scoring in mind, consider a case in which a client began therapy by discussing her struggles with weight control. Frames were presented that gave the history of her failed efforts to successfully manage her weight. The discussion included a description of how significant others in her life had tried to help her. These frames were all contextualized within the presenting gallery, "Weight control."

During this conversation in the presenting gallery, the client made the statement, "I wish I didn't care so much about how I look." This statement was an opening (Opening 1) to enter another gallery, in this case the gallery, "Self image." Here a variety of different frames were set forth all having to do with her self-image. Conversation in this gallery continued until she made the statement, "He can't stand it when other men look at me." This opening (Opening 2) shifted the conversation into the gallery, "Handling jealousy." Talk continued which presented frames that could hang on the wall of the "Handling jealousy" gallery. This became the therapeutic gallery where the woman's weight control problem could be contextualized as an interpersonal resource that contributed to stability of her marriage. Here the therapist and client were able to move toward exploring alternative, more effective ways of managing

relational patterns. The entire case can be scored using the conceptual tools of frames, openings, and galleries. A basic score of this case is shown in Figure One:

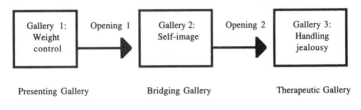

Presenting Gallery Bridging Gallery Therapeutic Gallery

Figure One

In another case, a couple sought therapy for the wife who was experiencing uncontrollable vomiting. This presenting gallery, "Vomiting," included frames that described the nature of her vomiting, its onset and duration, possible explanations, the involvement of others in attempted solutions and understandings, and so on. During this conversation, she made the statement, "He's always been a pain in the gut." This opening took the conversation into the bridging gallery, "Experiencing relationship." Here the couple presented frames describing the wife's experience of her marital relationship. Conversation remained in this gallery until she offered another opening, "I wish I could throw his insults back to him." This statement moved the conversation into a therapeutic gallery where the therapist and clients worked on tactics for helping her relate to insults. Figure Two shows the score for the case:

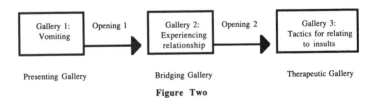

Presenting Gallery Bridging Gallery Therapeutic Gallery

Figure Two

In a third case, the presenting gallery concerned a young man's "Hallucinating." Therapy moved into a bridging gallery when he offered the opening, "Lots of people have said I'm very sensitive." Frames about "Sensitivity" were presented in this bridging gallery until another opening emerged: "I hear what other people don't want to know." From this opening, conversation moved into the therapeutic gallery where the "Social politics of secrets" could be addressed. The score for this case follows:

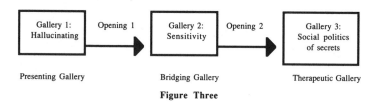

Figure Three

In another case, a man provided frames in the presenting gallery, "Depression." The first opening, "I heard on television that depression is repressed anger," moved the conversation into the bridging gallery, "Repressed anger." This, in turn, led to another bridging gallery that was opened by his statement, "The only person I'm angry with is my boss." Frames in this bridging gallery brought the conversation to another opening, "My boss is like my dad." With this entry into a therapeutic gallery, the conversation focussed on working with the father-son relationship as practice in solving the boss relationship problem. The basic score follows:

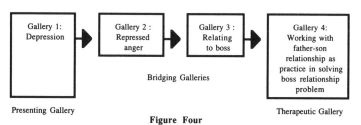

Figure Four

Figure Five is a case score in which the presenting gallery was a "Problem adolescent." Here, the parents set forth frames that kept conversation in this presenting gallery. The therapist created an opening with the following statement to the adolescent: "Imagine you were picked up by a flying saucer and, after a speed-of-light journey to another galaxy, you came back fully enlightened. How would you have to act to assure you wouldn't drive your parents crazy with your new superiority?" With this opening, the conversation moved into a bridging gallery that evoked frames about the "Problem of enlightenment." Frames in this gallery eventually moved conversation into the therapeutic gallery where resourceful frames helped the family in "Managing two worlds" -- those of adolescents and parents.

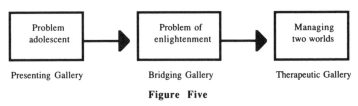

Problem adolescent	Problem of enlightenment	Managing two worlds
Presenting Gallery	Bridging Gallery	Therapeutic Gallery

Figure Five

Creating Clinical Case Scores

Consider the case stories, transcripts, audio and video tapes of all the clinical casework that has ever been published. In addition, consider the audio and video recordings one can collect of one's own work. Each of these cases can be outlined in brief form using the method of scoring conversation in therapy described here.

Creating a clinical case score requires identifying the progression of galleries, noting the openings, and keeping track of any interesting or relevant conversational moves. With this method, a brief score, usually limited to one page, highlights the flow of therapeutic conversation with redundancy and noise eliminated. The two scores that follow were created

from full clinical case transcripts published in *Mind in Therapy* (Keeney and Ross, 1985).

Handling Masturbation

Figure Six presents the score for a case Jay Haley supervised in which a ten-year-old boy with a masturbation problem was treated by John Lester, who, at the time, was a trainee at the Philadelphia Child Guidance Clinic.

The women in a family presented a boy whose masturbation habit was so severe he would sometimes wear holes in the crotch of his pants, and at one time was hospitalized for blood in his urine. Furthermore, he masturbated in public, at school, or at home in the living room in front of his sisters. Frames describing attempted solutions revealed previous therapy based on a reward and punishment strategy, Dexadrine, and private tutoring.

The first major therapeutic move came when the therapist defined masturbation as a "private matter" for men. This opening shifted conversation from the presenting gallery in which women (the boy's mother and sisters) had attempted to handle problematic masturbation, to the bridging gallery, "Men handling problematic masturbation." Within this gallery, the therapist asked the mother permission for him, as a man, to assume leadership in handling the problem. This shift, along with a challenge to the mother as to whether she could really handle the change if it took place, enabled the therapist to move to an assignment. In the first assignment, the boy was instructed to write down how many times he masturbated during each day of the week.

The subsequent session began with a review of the boy's masturbation habits during the previous week. When the therapist asked on which day it felt best, the boy replied it was Sunday. The therapist explained that he asked this question because, "It is important that you

do enjoy it *all* the time." This conversation was an opening to move into the therapeutic gallery, "Handling pleasurable masturbation."

Within this therapeutic gallery, interventions were designed that prescribed a schedule for the boy to follow centered on this theme of handling pleasurable masturbation. At first, the boy was told to masturbate only on Sunday and to do it more often than usual on that day, because it is more pleasurable then. In the following session, the boy reported he didn't do the assignment, although he had his sister wake him up earlier on Sunday morning so he could get the job done.

Although the boy did not carry out the first assignment, the important point was that it established the frame that Sunday's masturbation is pleasurable. This resourceful frame hanging in the therapeutic gallery enabled the therapist to assign a second task: Masturbating on other days (days which aren't as pleasurable) means that the boy *must* masturbate more often on Sunday. The therapist had caught the boy in a fascinating paradox: If he did what the therapist assigned, he would be free to reward himself with pleasurable masturbation on Sunday. If he disobeyed the therapist, he was punished by being required to perform pleasurable masturbation on Sunday. Either way, the boy was kept in the therapeutic gallery, "Handling pleasurable masturbation."

Within this gallery, the therapist helped the boy reach a satisfactory conclusion to the therapeutic story several sessions later. The score for this case follows:

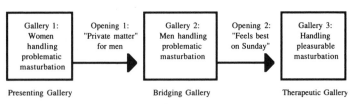

Figure Six: Handling Masturbation

600 Miles of Solitude

Figure Seven presents a more detailed score of a case, showing a number of bridging galleries that eventually led to the therapeutic gallery where resourceful frames could be elicited and utilized. This score is from a single session with a family already in treatment in which Luigi Boscolo and Gianfranco Cecchin served as consultants (for a detailed case transcript, see Keeney and Ross, 1985).

A mother and father had brought their daughter, Mary, to therapy for treatment. The session began in the presenting gallery of a "Sick child," where frames defined Mary as having epileptic seizures, hallucinations, temper fits, an inability to leave home, and failure to attend therapy. The parents defined the immediate problem as one of medication control, since medicine had always worked in the past from the time Mary was 10 years old until now at age 18.

Mother provided an opening to another gallery when she mentioned that her daughter was "unusually emotional." Subsequent discourse within the gallery, "Sensitive child" set forth frames describing Mary as having frequent crying spells and blaming herself for her problems.

This talk about "blaming" became an opening when the therapist asked about Mary's attachments to others. Moving into the "Family attachments" gallery, the family provided frames describing Mary as closer to Mother. With Father away on frequent business trips, Mother and Mary spent more time together at home. In addition, the family lived 600 miles away from any other relative.

When Mother described herself as "introverted," the therapist seized this as an opening for moving into the gallery, "Introverts and extroverts." Here Mary and Mother were both described as introverts, and Mary subsequently disclosed her lack of involvement with anyone in her own age group. When Mary said she wished she were an extrovert like her father, the therapist

introduced the possibility that if Mary were to join Father as an extrovert, Mother might feel left out.

"Being left out" provided an opening to the gallery, "History of family solitude." Here Mother presented frames describing her history of being left by significant others. She mentioned the close relationship she enjoyed with her mother-in-law, Grandma Elsie, who had passed away. Mother stated, "I was most attached to my mother-in-law, and I suppose that has a lot to do with Mary because Mary (was) her only girl grandchild." The onset of Mary's symptomatic behavior was several years after Grandma Elsie's death.

This became the opening leading to a final therapeutic gallery. Within this gallery, "Prescribing Mary's behavior as a family solution," the therapists could offer frames describing Mary as the person most able to replace the emptiness her parents felt when Grandma Elsie died. She was instructed to continue helping her parents avoid lonliness by providing opportunities for them to parent her around the clock. Furthermore, the family was told to keep things as they were until Mary's parents could find another way of handling the family's solitude.

This therapeutic gallery became a resourceful context, and the family was able to resolve their situation a few sessions later.

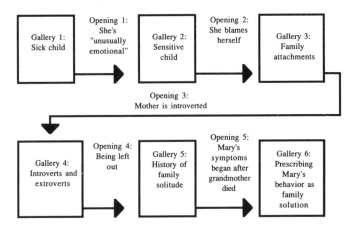

Figure Seven: 600 Miles of Solitude

On Creating Therapeutic Galleries

As the previous cases demonstrate, central to this method of scoring is the primary objective of moving conversation into a therapeutic gallery. With this in mind, therapeutic practice, supervision, training, and consultation are organized by three general concerns:

1. Have useful frames and bridging galleries been elicited that enable construction of a therapeutic gallery?
2. Has a therapeutic gallery been built?
3. Has the therapeutic gallery been maintained successfully?

Once built, the therapeutic gallery emerges as a primitive structure with minimal scaffolding. As conversation continues in the course of therapy, the client presents frames that, when fully utilized, help maintain the therapeutic gallery. Whether a client presents straightforward outcome information, new requests, unusual complaints, off-the-wall utterances, or wild noises, the skilled therapist is able to weave these frames into new layers of scaffolding, thus maintaining and strengthening the therapeutic gallery.

Occasionally, therapists and clients drown in an overabundance of frames. When this happens, the therapist must re-elicit and emphasize frames that he or she believes will be most useful in building the gallery and getting on with the next stage. Sometimes a primitive gallery emerges, but it leaks to such an extent that conversation oscillates between being focused and being all over the place. In this situation, the therapist must "plug the leaks" and begin spinning a web that maintains the therapeutic gallery.

Implications for Psychotherapy

This method of scoring conversation in therapy is useful to the practice and understanding of any therapeutic orientation. Schools of therapy are simply ways of prescribing particular interventions and particular interpretations that help therapists construct and maintain a therapeutic gallery. For example, Ericksonian therapists build an Ericksonian therapeutic gallery within which Ericksonian-style interventions may be prescribed. Psychodramatists require a psychodrama gallery within which to do their work. The same is true for experiential therapists, gestalt psychotherapists, and so on, ad infinitum.

Like musical notation, therapeutic scores free the therapist to utilize any genre of therapy, without encouraging a naive effort to "integrate" logically distinct therapeutic orientations. Often, unsuccessfully integrated approaches become forms of nonsense generated when one orientation prescribes frames that create leaks in the therapeutic gallery of another orientation. Successful integrations are possible, however, when they give rise to a therapeutic orientation not necessarily having any resemblance to the original ingredients -- that is, when they become the creation of something entirely new.

Although scoring can be applied to any school of therapy, it is still the author's belief that the notions of frame and gallery implicity encourage a therapist to develop a *systemic* understanding. Since this method is principally a way of underscoring the *context* of therapeutic conversation, it follows that examining contexts and contexts of contexts will lead the therapist more often than not to the systemic organization of conversation.

This is another way of saying that an emphasis on context leads again and again to the initial systemic insight -- a person's experience is always a product of his or her context. The distinction between individuals and families is less a paradigmatic difference than the

move to seeing individuals-in-context and families-in-context.[2]

In conclusion, a score of therapeutic conversation provides a way of understanding and organizing therapy by viewing it as a walk through an art exhibition. In the reception area of an exhibition, like the waiting room of a clinic, the patron or client await the possibility of moving through a wide variety of galleries. In therapy, the participants move from frame to frame and gallery to gallery, searching for a context that will be resourceful. If clients and therapists become stuck in their frames, they may simply move to another gallery. Therapists may grab clients and drag them into other galleries or they may wait patiently until the client moves near a door before giving a gentle push. There are many ways to guide people through an art exhibition or through a therapeutic gallery. As Confucius once said and as all good curators and therapists know, "The way out is through the door."

[2]The theoretical underpinnings of scoring has been articulated in previous works (Keeney, 1983; Keeney and Ross, 1985; Keeney and Silverstein, 1986).

Chapter Five

THERAPEUTIC MOVES:

Creating Openings, Connections,

and Disconnections

The performance of music, theatre, dance and psychotherapy involves more than a simple progression of moving from beginning to middle to end. Each artistic practice has its own aesthetic devices, embellishments, voicings, and moves that give it unique form and texture. This chapter presents an array of aesthetic tools therapists and clients can use to construct, deconstruct, connect, disconnect, relate to, and manage the progression of frames and galleries in therapy.

What follows is a comprehensive collection of the rhetorical devices used in therapy, organized in the two general categories "therapeutic distinctions" and "therapeutic moves." The former refers to how frames and galleries contextualize therapy, whereas the latter concerns the rhetorical maneuvers or clinical techniques used to move a session toward becoming therapeutically resourceful.

The chapter begins with an overview of these distinctions and moves presented in outline form. The section following the overview offers a detailed description of each, along with clinical examples and pictorial representations. These representations (called "figures of speech" by Chenail, 1990) serve as icons for helping the therapist immediately visualize and conceptualize each therapeutic distinction and move. The chapter concludes with a brief case study, demonstrating how these distinctions and moves can be used to understand clinical work.

Overview of Therapeutic Distinctions and Moves

I. Therapeutic Distinctions

A. *Orders of Framing*
 1. Content of Frame, Frame, Gallery, and Wing
B. *Markers*
 1. Entrance Markers
 2. Exit Markers
 3. Frame Markers
 4. Rim Markers

II. Therapeutic Moves

A. *Content to Frame Relations*
 1. Emptying/Clearing a Frame
 2. Opening a Frame
 3. Frame Destruction
 4. Same Frame, Different Content
 5. Out-of-Frame Discourse
 6. Misframe
 7. Frame Reversal
 8. Splitting/Dividing a Frame
B. *Frame to Frame Relations*
 1. Frame Next to Frame
 2. Connecting Frames
 a. Frame Connected to Frame
 b. Frame Connected to Gallery
 c. Gallery Connected to Gallery
 3. Disconnecting Frames
 4. Chunking Frames
 5. Weaving

I. Therapeutic Distinctions

The term, "therapeutic distinctions" refers to the way clients and therapists contextualize their situation through casting distinctions that name and indicate.

"Orders of Framing" and "Markers" are the two basic categories of therapeutic distinctions that refer to ways of distinguishing or indicating context in therapy.

A. *Orders of Framing*

1. Content of Frame, Frame, Gallery, and Wing

The previous chapter introduced a basic method for scoring conversation in therapy using the distinctions, *frame* and *gallery.* The basic underlying idea was that people's communicative acts provide a context or frame for other communicative acts. The notion *gallery,* for instance, is used to indicate a framing of frames. Galleries, in turn, can be framed or contextualized by other, higher order framings. For instance, a whole class of galleries can be called a "wing" and a collection of wings, a "museum." A particular example of a wing could be "psychotherapy," while the museum housing it could be the entire "mental health profession."

On a clinically practical level, any message, communicative act, statement, or what actors in a play would simply call a "line," can be considered a frame, the content of a frame, a gallery, or any other order of framing. For instance, the line, "Our son was arrested for stealing home plate," could be contextualized as a particular *frame* within the *gallery,* "Son's Problem Behavior." In this gallery, other frames would be elicited that provide examples of the son's problem behavior. The gallery might look like this:

Gallery: Son's Problem Behavior

Frame 1: Arrested for stealing home plate
Frame 2: Doesn't act his age
Frame 3: Refuses to do his chores,
 especially kitchen cleanup

One could, however, choose to use the line, "Arrested for stealing home plate," as the name of a *gallery* containing its own subset of frames:

Gallery: Arrested for Stealing Home Plate

Frame 1: The janitor called the police
Frame 2: Son is high school baseball star and had key to stadium gate
Frame 3: Son made a lot of noise that woke up the neighborhood

Of course, this gallery, "Arrested for Stealing Home Plate," can be understood as embedded within the former gallery, "Son's Problem Behavior." Taking this a step further, we can conceptualize the gallery, "Son's Problem Behavior" as being embedded within a larger order frame, say the "wing" of his family relations. Here we might find a busy professional father who is seldom at home. Contact with his son is limited to baseball games, which he never misses. Perhaps the recurring theme in this family is "Getting Dad Home."

In the wing, "Getting Dad Home," the son's "problem behavior" appears to be a solution. Perhaps the son steals home plate as a way of getting Dad more involved with what's happening at home. Most interesting about these different framings is the notion that each order of framing can be arranged and understood as being embedded within the other.

In summary, a *frame* at one order of understanding appears as the *content* of another frame when viewed from a different order of understanding. Determining whether a conversationalist's line or statement is a frame, the content of a frame, a gallery, or a wing depends upon how one discerns its embeddedness -- that is, if one sees it as a part or as a whole.

In our present example, we have discussed these major lines:

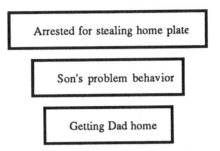

There are many possibilities for part/whole relations or embeddedness. For instance:

Embeddedness Pattern 1

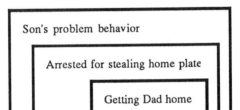

This pattern of embeddedness contextualizes the therapeutic story to be principally about the son's problem behavior. Being "arrested for stealing home plate" is only one example of his problem behavior. When the frame, "Getting Dad home" is embedded within the frames, "Son's problem behavior" and "Arrested for stealing home plate," it will most likely be understood as one ingredient or detail contributing to *why* the son was arrested or *why* the son is a problem. Most bluntly stated, this pattern of embeddedness too easily suggests that bad fathering has led to a bad son. The therapist caught in such a web of understanding is tempted to try correcting the pathologies of each male.

Notice the shift that takes place with another pattern of embeddedness:

Embeddedness Pattern 2

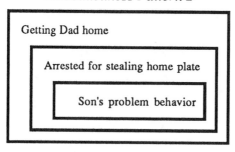

In this pattern, as we've mentioned, the son is offering solutions to help Dad get more involved in family life. A therapist in this web of understanding does not have to treat sick, disturbed, or bad individuals, but may serve as a consultant to helping solve a family dilemma. This order of framing contextualizes the problem in a more positive fashion.

Exercises:

For each of the following sets of conversational "lines" or presenting communications, create different forms of embeddedness (i.e., part/whole orderings) and discuss implications for therapeutic action arising from them.

Case 1
- Mother's depression
- Father more involved in career
- Daughter leaving home

Case 2
- Student is anxious over exams
- Student has insomnia
- Student's best friend is a successful artist

Case 3
- Wife has many outside friends
- Husband has no outside friends
- Couple's pet dog is diagnosed as "neurotic"

B. Markers

Markers are signs that provide specific information about how frames are to be understood. Some markers indicate openings and, like highway signs, point to entrances and exits. Other markers provide information about the creator of the frame, while others specify how the content of the frame is to be taken.

1. Entrance Markers

An entrance marker points to a specific kind of opening that invites or directs the participants to move conversation into a new gallery. When a therapist asks a client, "What's the problem?" a marker is presented that invites the client to enter the gallery, "The Problem," where frames may be elicited that define, give historical background, and describe attempted solutions for the problem:

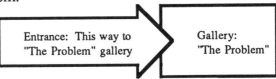

Entrance: This way to "The Problem" gallery

Gallery: "The Problem"

Gallery Entrance Marker

Gallery entrance markers may be concrete, ambiguous, or entirely vague. Examples include:

CLIENT: We need to have a third party hear about our situation. *(Entrance to "Hearing about our situation" gallery)*

CLIENT: We know what the problem is. We just don't know what to do about it. *(Entrance to "What to do about it" gallery)*

THERAPIST: We know what the solution is. We just can't get motivated to do it. *(Entrance to "Getting motivated" gallery)*

CLIENT: We'd like to discuss our marriage. *(Entrance to "Marriage" gallery)*

CLIENT: My doctor said you could tell us how to straighten out our kids. *(Entrance to "Straightening out kids" gallery)*

THERAPIST: Let's get some background information on your family histories. *(Entrance to "Family histories" gallery)*

THERAPIST: What happened that helped you decide you needed to see a therapist? *(Entrance to "Decision to see therapist" gallery)*

THERAPIST: Where do you want me to take you from here? *(Entrance to "Where else to go?" gallery)*

THERAPIST: If things were better, where would you be? *(Entrance to "Better situation" gallery)*

THERAPIST: Can you imagine things getting so much better that even you wouldn't believe it? What's a positive change you don't believe you could ever achieve? *(Entrance to "Unbelievable success" gallery)*

Exercises:
Consider three different clinical cases, real or imaginary, in which the therapist and clients feel stuck in the presenting gallery. Name the presenting gallery for each case and provide three frames that are hanging in it. After you have done this:
1. Create a statement for each case that would indicate an entrance to a new gallery.
2. Create one statement that would provide an entrance marker for all three cases.
3. Think of a statement a client could have made in each case that would be an entrance marker you could utilize for that case.

2. Exit Markers

An exit marker points to a specific kind of opening that indicates one is about to exhaust, complete, or leave a gallery. An obvious example of a gallery exit marker would be a client's statement, "I give up":

Gallery Exit Marker

Other examples follow:
> "There must be something we haven't tried."
> "We've tried everything."
> "I can't stand to talk about it anymore."
> "That's all I know."
> "Are we at the end of this discussion?"
> "And so you lived miserably ever after."
> "I want out of here."
> "Let's move out of this discussion."
> "So that's your story so far. Are you ready to go to the next chapter?"
> "Do you want to take an exit from this never-ending story?"

Exercises:
Consider three different clinical cases, real or imaginary, in which the therapist and clients feel stuck in the presenting gallery. Name the presenting gallery for each case and provide three frames that are hanging in it. After you have done this:

1. Create a statement for each case that would indicate an exit from the gallery.

2. Create one statement that would provide an exit marker for all three cases.

3. Think of a statement a client could have made in each case that would be an exit marker you could utilize for that case.

3. Frame Markers

Some frames in an art gallery have information on or under them about the artist, the medium used, the date, location, style, and so on. In therapeutic discourse, frames are sometimes marked in a similar way, providing information about the creator. For example, when a client says, "The psychiatrist is the one who said he's a 'borderline'," a frame marker has been suggested:

```
+-------------------------------------+
|                                     |
|                                     |
|              Gallery:               |
|             "Borderline"            |
|                                     |
|                                     |
+-------------------------------------+
      +-----------------------------+
      |         Created by:         |
      |        Dr. Diagnosis        |
      |        DSM III Avenue       |
      +-----------------------------+
```

Frame Marker

Other examples of statements indicating frame markers include:

"My sister is a psychic. She always predicted he'd get into trouble."

"The minister, after all, is an expert on spiritual crises."

"In my research with anorectics, the data demonstrates that it's usually a family problem."

"Look, I'm the expert who knows about this."

"Therapists say those sorts of things."

"Family therapists never say those things."
"Systemic therapists say things that even surprise themselves."
"I don't know why I said that -- it must have been my unconscious."

Exercises:
Consider one gallery from any clinical case, real or imaginary:
1. Create three different frame markers for that gallery.
2. Consider the different directions and possibilities that arise from these different markers.

4. Rim Markers

Following Erving Goffman (1974), the rim of a frame may indicate how the content is to be taken, typically in terms of "real" or "fiction." The rim of a window frame suggests that what is seen through the window is "real," whereas the rim of a picture frame suggests that what is seen in the frame is "fiction." Of course, rim markers may be more complicated, suggesting that the content be taken as real fiction, fictional reality, ambiguity (real or unreal), sense, nonsense, sensical nonsense, nonsensical sense, or confusion. The following statements demonstrate two exemplary rims:

"I can see clearly through the window of your reality."

"Forget the psychiatrist's diagnostic fictions. He's painting the wrong picture of you."

Rim Markers

Other statements that could suggest rim markers include:
"That's the real problem."

"Sometimes I think it's unbelievable."
"This is a Western."
"It's Gothic."
"We're in *Alice in Wonderland*."
"Isn't this ironic?"
"No, it's a parody."
"It's really more like realism."
"That's science fiction."
"Let's pretend we're pretending."

Exercises:
 Consider one gallery from any clinical case, real or imaginary:
 1. Create three different rim markers for that gallery.
 2. Consider the different directions and possibilities that arise from these different rim markers.

II Therapeutic Moves

 The next two basic categories in our inventory, "Content to Frame Relations" and "Frame to Frame Relations" specify the wide range of rhetorical moves that therapists usually regard as therapeutic techniques and interventions. These moves provide the means for moving discourse into a therapeutic gallery and maintaining it there. The therapist is invited to practice these moves by creating more examples to add to the lists that follow the description of each move. In addition, an audio or video tape of the therapist's work can be reviewed with the specific task of identifying moments when one of these therapeutic moves could have been introduced.

A. Content to Frame Relations

1. Emptying/Clearing a Frame

 The category, "Content to Frame Relations" concerns the relation of the inside of a frame to the frame itself. The first move, "Emptying/Clearing a Frame,"

refers to ways of emptying or clearing the content of a frame or that of a whole gallery. An "Etch A Sketch" provides an analogy. When a person has completed sketching on this toy, there is a simple operation to clear the inside of the frame -- you shake it and the lines dissolve. Rhetorical moves that have the same effect of clearing the content of a frame are exemplified in the following lines:

"Take three breaths. Now think about which one felt the best -- the first, second, or third. Try it again. This time, really remember it."

"Stand up and shake your whole body until your mind is clear."

"Erase and try again."

"Do you know about an 'Etch A Sketch'?"

2. Opening a Frame

One way to get out of a frame is for it to spring a leak. Here the therapist purposefully creates questions evoking answers from a client that lead to openings toward another frame or gallery. Examples:

"Who would say, 'That's not it at all'?"

"What would have to happen to make you doubt what you just said?"

"When did you decide to believe that? What did you think before?"

"What's going on with you all that doesn't fit into what you've been telling me?"

"Is there anything about your situation that contradicts everything you've been telling me?"

3. Frame Destruction

The meaning of this move is obvious: eradication of a whole frame or gallery. Examples:

"Let's torch that explanation."

"Let's throw everything we've just said out the window."

"Now make believe you forgot that you forgot."
"Make believe you forgot that ever happened."
"Forget it!"
"Forget everything we've said."

Note that the difference between "Emptying/Clearing a Frame" and "Frame Destruction" is that in the former, the therapist chooses to eliminate the content of a frame while keeping the frame or gallery itself. In the latter, the therapist chooses to eliminate the entire frame or gallery along with its content.

4. Same Frame, Different Content

Using the same frame, different content is introduced. Examples:
"Would this explanation apply to anyone else you know?"
"Has this happened to anyone else you know?"
"Does this understanding explain other parts of your life?"
"I've heard that from another family I treated."
"Did you see that new movie? It's your story."

5. Out-of-Frame Discourse

Therapists have long known the utility of following an intuition or free association that, at the time, does not seem to connect with the ongoing discourse. This "Out-of-Frame Discourse" often brings surprising resources to the therapeutic conversation, helping to move participants into other frames and galleries. During a conversation with clients, a therapist may interrupt with out-of-frame statements similar to the following from actual cases:
"There goes that odd noise again."
"Fascinating, I think we're in waltz time."
"Did you see that falling star last night?"

"'Go to the other side' -- Excuse me, I just remembered what I should have told my last client."

"Do you fish? I was just wondering about this weekend's forecast."

"Damn! I can't get that tune out of my head."

"Did Einstein paint? Never mind, you're probably not ready for that one."

"Did you realize that no one really knows whether Egyptians ever laughed? There's no indication."

"Have you ever had a real belly laugh? Are you sure? Experts say Americans stopped belly laughing after the depression."

"Have you heard of Dr. Mises? He actually counted the number of angels on the head of a pin."

"Do you understand rhetorical juggling? (pause) It doesn't require that you catch it."

"Out-of-Frame Discourse" can arise from other resources such as the therapist's library or file cabinet. Pulling a book off a shelf, presenting it to a client and saying, "Read this title," is an easy way to shift therapeutic conversation. The title of the book could provide the name of a new gallery for the therapist and client to enter. Some favorite published book titles include:

Kicked a Building Lately?
The Ox on the Roof
The Jungle is Neutral
True Tales from the Annals of Crime and Rascality
Sourdough Sagas
Ask the Right Question
I Came From the Stone Age
Blind White Fish in Persia
Come, Tell Me How You Live
No Room in the Ark
The Kitchen Sink Papers: My Life as a Househusband
The Female Man
Is Sex Necessary?

Honor to the Birds Like the Pigeon that Guards Its
 Grain Under the Olive Tree
Living Well is the Best Revenge
The Mother Knot
The Holy Terrors
The Psychology of Clothes
What the Trees Said
Peacock Manure and Marigolds: A "No-Poison"
 Guide to a Beautiful Garden
The Autobiography of a Super-Tramp
The Modern Day Fly Code
You Can't Steal First Base
Baseball When the Grass Was Real
Every Great Chess Player Was Once a Beginner
Murder Must Advertise
A Zoo in My Luggage
Am I too Loud?: A Musical Autobiography
The Bad Popes
A Texas Cowboy, or Fifteen Years on the Hurricane
 Deck of a Spanish Pony
Silence
You Can't Take it With You
Blackstone's Tricks Anyone Can Do
Learned Pigs and Fireproof Women

6. Misframe

Misframes involve the deliberate use of erroneous framing that may help create openings to other frames or galleries. Examples:

CLIENT: I don't know what to do with my life.
THERAPIST: What have you been doing with your wife?

CLIENT: She makes me so angry.
THERAPIST: What else does she do to get you sexually aroused?

CLIENT: I'm pissed off.
THERAPIST: How did you get so turned on?

CLIENT: We've been round and round all this before.
THERAPIST: So you're a couple of squares?

CLIENT: She's impossible!
THERAPIST: You're mistaken. The name of the song is actually "It's Impossible." It was Perry Como's big hit.

CLIENT: No! No! No!
THERAPIST: Are you interested in Japanese theatre? Don't tell me you don't know that Noh's the name of a kind of Japanese theatre nothing like anything you've ever seen before. No know Noh?

7. Frame Reversal

In this rhetorical move, the content becomes the frame or the frame becomes the content. Like a Chinese box, the inside becomes the outside, or the outside becomes the inside. Examples:

CLIENT: I can't make a choice.
THERAPIST: When did you decide that?

CLIENT: I'm a failure and I disappoint everybody.
THERAPIST: If you were to successfully achieve a full-blown authentic and complete failure, who would be the most pleased?

CLIENT: There's no way out.
THERAPIST: That's one way out.

CLIENT: I don't know where to begin.
THERAPIST: That's the best place to begin.

CLIENT: I really hate him!
THERAPIST: Who else do you love hating?

CLIENT: I don't want to love him.
THERAPIST: Who else do you hate loving?

CLIENT: I got framed.
THERAPIST: Are you always photogenic?

CLIENT: I won't say no.
THERAPIST: Congratulations, you just did.

CLIENT: I don't have the energy to change.
THERAPIST: How much work and energy and motivation and willpower and desire and perseverance and skill and resourcefulness does it take to fight off everyone's efforts to change you?

THERAPIST A: There's no such thing as homeostasis. Everything's always changing.
THERAPIST B: Do you still believe there's no such thing as homeostasis?
THERAPIST A: Absolutely.
THERAPIST B: Isn't this "homeostasis of *no* homeostasis"?

THERAPIST A: Real is really real.
THERAPIST B: Is that how you choose to see it?

THERAPIST A: Everything is constructed by an observer.
THERAPIST B: So that's how it *really* is?

THERAPIST A: Good therapy never gives answers; it only asks questions.
THERAPIST B: Questioning is the answer?

8. Splitting/Dividing a Frame

In this move, the therapist splits the content of a frame to bring forth a difference. This difference provides a resource for changing the course of therapeutic conversation. Examples:

"When during the week are you the least bothered and when are you the most bothered?"

"If you had the anxiety attacks only in the mornings, what would your afternoons and evenings be like?"

"Imagine being secretly married to two people."

"Who are two people, completely the opposite, that you'd like to be like?"

"Let's discuss the advantages and disadvantages the depression provides."

"How is that advantage a disadvantage? How is that disadvantage an advantage?"

"How would your husband be different if he had grown up in your family?"

B. Frame to Frame Relations

The final basic category in our inventory concerns the relation of whole frames (content and frame) to other whole frames.

1. Frame Next to Frame

With this rhetorical move, one does not attempt to open or destroy a frame, or even find a bridge or connection between frames. A different frame or gallery is simply set next to another frame or gallery. Whereas "Out-of-Frame Discourse" is a more spontaneous, unconscious free association by the therapist, a "Frame Next to Frame" move is more consciously and purposefully spoken. Examples:

"Let's not forget this is a _____ (hospital, university, church, business, clinic, etc.)."

"(Artists, engineers, scientists, judges, politicians, etc.) have interesting ways of handling their situations."

"This is a weird thought. You know I just realized I've never had a failure with _____ (Buddhists, bikers, rockers, hippies, etc.)."

"Did you ever have an intense talk with a stranger on an airplane?"

"If you saw the therapist next door, she'd probably say the opposite."

"We all know what Freud would say."

"What do you think Woody Allen would say we need to be talking about?"

2. Connecting Frames ☐⊢☐

This section, "Connecting Frames" includes three logically distinct categories: "Frame Connected to Frame," "Frame Connected to Gallery," and "Gallery Connected to Gallery." Each type of connection offers a very specific way of using the operation "Splitting/Dividing a Frame" (described on the previous page) in order to connect frames in particular ways.

a. Frame Connected to Frame ⊡⊢⊡

In this move, a frame is connected to another frame within the same gallery, as the following examples demonstrate:

CLIENT: I can't stand him.

THERAPIST: When do you find yourself most able to stand him? Least able to stand him?

(Connected frames within the gallery, "Standing Him")

CLIENT: Everything would be okay if I could become a success at anything.

THERAPIST: Do you think your criteria for success will get tougher next year? *(Connected frames within the gallery,"Success")*

CLIENT: We're scared.
THERAPIST: Who else is scared? *(Connected frames within the gallery, "Scared")*

CLIENT: I'm too concerned about my daughter.
THERAPIST: When did you first know that? *(Connected frames within the gallery, "Concern")*

b. Frame Connected to Gallery

This rhetorical move involves connecting a frame within one gallery to an entirely different gallery. Its operation involves splitting the frame so that the two emergent frames belong to different galleries. Examples:
CLIENT: I can't stand him. *(Frame within the gallery, "Who can't stand him")*
THERAPIST: Who likes him? *(The gallery,"Who likes him")*

CLIENT: Everything would be okay if I could become a success at anything. *(Frame within the gallery, "Failure")*
THERAPIST: Can you imagine being so successful, no one would believe it? *(The gallery, "Success")*

CLIENT: We're scared. *(Frame within the gallery, "Scared")*
THERAPIST: Who's not scared? *(The gallery, "Not scared")*

CLIENT: I'm too concerned about my daughter. *(Frame within the gallery, "Concern")*
THERAPIST: Who are you not very concerned with? *(The gallery, "Not concerned")*

c. Gallery Connected to Gallery

In this rhetorical move, frame to frame connections within one gallery are connected to another gallery. This operation involves a sequence of two steps. First a frame is split, establishing a gallery containing the emergent two frames. This whole gallery is then connected to another gallery which is logically distinct but closely related. Examples:

CLIENT: I can't stand him.

THERAPIST: Who else can't stand your brother?

CLIENT: My father. (*Frames within the gallery, "Standing brother"*)

THERAPIST: Are you on good terms with your dad? (*The gallery, "Father-son relationship"*)

CLIENT: Everything would be okay if I could become a success at anything.

THERAPIST: Was there ever a time when you didn't feel that way?

CLIENT: When I was with my first wife. (*Frames within the gallery, "Success/failure"*)

THERAPIST: How does it feel when you see how different your second marriage is from your first? (*The gallery, "Marriage"*)

CLIENT: We're scared

THERAPIST: Who's not scared?

CLIENT: Our teenage son. (*Frames within the gallery, "Scared"*)

THERAPIST: Do you think you'll have trouble accepting his transistion from adolescence to adulthood? (*The gallery, "Developmental transition"*)

CLIENT: I'm too concerned about my daughter.

THERAPIST: What are you more concerned about?

CLIENT: Grandfather's retirement. *(Frames within the gallery, "Family concerns")*
THERAPIST: Who in the family is worried about your being a good father? *(The gallery, "Fathering")*

3. Disconnecting Frames

This rhetorical move disconnects frames by declaring they don't belong to the same gallery. Examples:
"There's absolutely no connection."
"Let's get that disconnected."
"Let's tease that apart."
"It doesn't compute."
"You're comparing peaches and coconuts."
"It's like you live in two different families."
"What if the hospital made a mistake? How do you know this is really your child?"

4. Chunking Frames

At any time during a therapeutic conversation, the therapist or client can chunk frames together, creating a higher-order, more encompassing gallery. Examples:
"What we're talking about is how to get on with your life."
"All that talk is about the past."
"This is just talk."
"We haven't started therapy yet. I'm still gathering information."
"We're out of time. Now I know about your conscious understanding. Next week let's explore what your unconscious has to say."
"Everything you've told me has to do with your concerns about your family's future."
"So those are all complaints. Are there others to add to your list?"

5. Weaving

The final distinction in our inventory, "Weaving," is the most complex rhetorical activity in psychotherapy. It involves taking whatever frame a client proposes and utilizing it as further evidence that their conversation belongs within the established therapeutic gallery. In this way, the initial scaffolding of a primitive therapeutic gallery is elaborated into a fully well-formed structure.

As an exercise, one could try weaving together all the conversational examples from the "Connecting Frames" section (#2 a, b, c), in a way that maintains and strengthens a therapeutic gallery. Although any gallery could be chosen, in the following example weaving is based on the therapeutic gallery, "How the family manages its future concerns":

> It's an interesting situation. If you were to become too successful too soon, you and your wife might feel even more uncomfortable about your present situation. However, continuing to complain about your career gives your wife the opportunity to show her concern and support. Your son, on the other hand, is taking steps toward becoming a man, and is practicing not being scared. This also may be helpful to grandfather and the rest of the family by showing that a life stage change can be accepted without excessive concern. Your daughter, on the other hand, helps by keeping you preoccupied enough that you do not get overly concerned with your career and the other members of the family. She will continue to complain about her brother and mother as long as she senses that you need to be distracted from your other concerns. At this time, I recommend not changing anything too quickly until we can get an even clearer understanding of how this family helps each other out with their concerns about the future.

Brief Case Study:
"The Waiting Room"

The author was invited to serve as a consultant to a case in which a family was being treated at a family therapy clinic. In a presession meeting the therapist, Ron Chenail, summarized the presenting problem -- a 19-year-old daughter who had been seeing doctors and psychotherapists for fifteen years. She was presently undergoing medical assessment for headaches and fainting spells.

Since the previous session had concluded with participants in the presenting gallery, "Problem Daughter," the consultant suggested the therapist begin this session by asking the family to explain to the consultant behind the one-way mirror what they thought they were working on. The mother immediately stated, "I don't know -- I have no idea what we're working on."

From the perspective of scoring, the mother's reply was an *exit marker* for leaving the gallery, "Problem Daughter." The next step was to elicit frames that would point the way toward eventually constructing a therapeutic gallery. Accordingly, the therapist's next question, "Is it medical or psychological?", served to *split* the original presenting gallery into two frames. Conversation could then move into the emerging bridging gallery, "Medical or Psychological?".The mother entered this bridging gallery by presenting frames that built a medical description. These frames included the daughter's allergies to almost all conceivable physical substances, headaches in the front of her head (medical) and back of her head (psychological), a 15-year-long history of waiting for medical test results, fainting at school, and recent concern from the Dean of Women Students that her daughter was a drug addict because she took so much medication.

Next the therapist requested that the mother describe what was "psychological." She immediately provided frames that built a psychological description, saying her daughter was socially unacceptable and

immature, severely depressed, had trouble adjusting, making friends, keeping friends, was nervous, a persistent worrier, and a crier.

Note that no connection is made between the two frames, "Medical" and "Psychological." They are simply placed next to one another (a *Frame Next to Frame* operation) within the bridging gallery, "Medical or Psychological?".

At this stage, sufficient frames and galleries have been elicited to make a move toward building a therapeutic gallery. The therapist does this by telling the mother and daughter, "The family has been living the last fifteen years of their lives in a waiting room." When he posed the question, "How long are you willing to wait in the waiting room?", the mother immediately replied, "I'm most impatient! It's time you and all these doctors and therapists gave us some advice."

By *chunking* together frames hanging in the bridging gallery, this conversation served to construct the therapeutic gallery, "Family in Waiting Room." A basic score for this session follows:

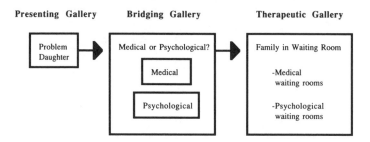

With the therapeutic gallery in place, the consultant entered the room and *weaved* frames and galleries to strengthen and confirm that all reports about family life are consequences of the family being stuck in a waiting room:

CONSULTANT: I once knew a family in New York City in which the parents were very wealthy and

sent their sick daughter to Switzerland, Johns Hopkins, and Harvard Medical School. She was 36 years old and had been seeing doctors and therapists since she was fourteen *(Same Frame, Different Content)*. Finally, the parents became so impatient they told their daughter, "That's it. Whatever you have, you have to learn to live with it. Live your life whether you feel like it or not." Look, as far as these headaches go, I know doctors who are experts on headaches *(Frame Marker)* and they suffer from headaches. They tell themselves to get up and go *(Same Frame, Different Content)*.

MOTHER: I know she can live with her headaches, but is she depressed?

CONSULTANT *(to daughter):* Did you dress yourself this morning?

DAUGHTER: Yes.

CONSULTANT: Did you fix your own hair?

DAUGHTER: Yes.

CONSULTANT: You see, depressed people can't do these things *(Clearing a Frame)*. They can't even get out of bed. The issue here is how much longer do you, Mom, need in order to get sufficiently impatient -- another five minutes or five years? *(to therapist:)* The solution to this situation will come when Mom and Dad get sick of the doctors. *(to mother:)* This is what Ron means when he says your family life has been in the waiting room *(Chunking)*. Does it feel like time has stopped since she was five years old?

MOTHER: Yes. But does she have the social skills to start?

CONSULTANT: Look at her. She's managed to make herself quite attractive. As we've seen here, she's also capable of engaging in a social conversation. Professional social skills training, the sort of thing you'd hire an expert for, is for people who don't know how to tie their own shoestrings *(Clearing a Frame)*.

MOTHER: I'm worried that she doesn't make friends.

CONSULTANT *(to daughter):* If you're stuck in a waiting room, how can you learn to make friends?

MOTHER: Is she really capable?

CONSULTANT: I don't know and you don't know. But we can find out. Tell her to get on with her life.

MOTHER: I'm worried that she's too lonely.

CONSULTANT: When she's lonely she gets a hold of you, right?

MOTHER: Yes.

CONSULTANT: So that helps. But it also blocks her opportunities to socially connect with young adults her own age. Has she ever rebelled?

MOTHER: Not really.

CONSULTANT: She needs to rebel. Children must rebel for two reasons: First it makes the parents angry and they're glad to get them out of the house when it's time for them to leave home. Otherwise, your heart would be broken. I have a four-year-old son. When I think about him leaving home, it starts to break my heart. Thank heavens my friends tell me that he'll turn into an adolescent nightmare and then I'll be delighted when he has to leave *(Frame Reversal)*. The other reason rebellion is important is that when your daughter gets upset with you, she'll want to turn to her friends and complain about how terrible parents are. This is how children get socialized *(Frame Reversal)*.

CONSULTANT *(to therapist):* What you need to do is get these two to have an argument. Perhaps they could argue about whether to continue therapy.

Maintaining the therapeutic gallery demands that a therapist practice the art of improvisation. Each rhetorical challenge from the client must be transformed into a resource and woven into a fabric of meaning that verifies the therapeutic gallery. It is here that the client can consider walking out of the waiting room door.

Chapter 6

HILDA'S GALLERY:

Composition of a Clinical Case

Bradford P. Keeney and Wendel A. Ray

Improvisation, whether in therapy or music, results in the composition of patterns that move and shape the process of composing. Whereas the previous chapters have demonstrated the scoring of clinical sessions that have already been conducted, this chapter turns to the improvisational process of composing a live case. Now we move from scoring as a method of reconstructing the events of a past session to scoring as a method of recording the composition of a clinical case in real time.

Throughout the conversations that follow, a therapeutic team worked on moving the client's rhetorical offerings into a therapeutic gallery. The flow of conversation required the team to improvise -- to create an ongoing clinical composition that, over several sessions, became a pattern helping move and shape therapeutic conversation.

Work on this case began following a first session, when therapist Wendel Ray and co-therapist Loren Bryant requested consultation from the author. A review of the first session videotape revealed the elicitation of a variety of problem definition frames from a 38-year-old woman named Hilda. In the gallery, "Hilda's Problems," frames included a history of weight problems (at one time weighing up to 300 pounds); her marriage to a "sexual deviant" who dressed up as a woman, had drug problems, and was employed as an

officer in charge of drug rehabilitation for a military base; her efforts to hide from people, including wearing dark glasses to avoid social contact and entering buildings from back doors; auditory hallucinations of people criticizing her; institutionalization for three months; present involvement in an affair with a married fundamentalist minister; a history of experiencing "little, short men creatures"; and a series of problem relationships with men which, along with a fear of going crazy, brought her to therapy. In addition to presenting these problem frames, Hilda described herself as being "very artistically inclined." Some of her paintings and sculptures were on display in a hospital showcase.

After examining this first session, the therapy team began constructing a way of using the frames presented to move the conversation toward a therapeutic gallery. Since Hilda described her immediate presenting problem as problem relationships with men along with a fear of going crazy, the therapy team began work at this starting point. Session Two began by trying to elicit a frame that would define Hilda's relationships with men as "crazy." If this could be accomplished, the first scaffolding of an alternative gallery would be built. By connecting the frame of her "crazy" relationships with men to the frame of her fear of going crazy, conversation could move into this alternative gallery. The second session unfolded as follows:

THERAPIST: You know, I was just listening to you all talk and was thinking about last week's session. And we had an idea, just a theory that came up. There are some other folks back there too, one or two of them - - colleagues. One of the things I remember from last week that was really pressing on your mind is that you kept saying that you were afraid of going crazy. That you were going crazy, right?

HILDA: Umm hmm.

THERAPIST: Afraid you were going to lose it, didn't know what was happening. And in thinking

about last week, you know what you said this week about what's-his-name? I can't remember.

HILDA: Leonard.

THERAPIST: About Leonard, and thinking about what you had talked about in the other relationships you were having -- had in your past. The kind of things that seem to be repeating here is that you seem to pick men that are crazier than you are.

HILDA: That (they) have more problems than me like alcoholics are attracted to other alcoholics.

Comments: The frame the therapists are proposing is being brought forth.

THERAPIST: Yeah.

HILDA: I know, but I mean I really don't set out looking for them.

THERAPIST: No, you don't go looking, but in a funny kind of way though, it may not be a bad idea if you do because, because, ah...

CO-THERAPIST: There could be benefits.

THERAPIST: There could be some benefits, some advantages. If you...

HILDA: Like, if I dig them out it makes me look better?

Comments: Hilda contributes to building the scaffolding of this emerging alternative gallery.

THERAPIST: And what we are saying is that in a kind of crazy way, this is a real innovative and good solution that you've come upon for right now, okay? Not forever, but for right now. 'Cause it distracts you from having to deal with or be concerned with the craziness part of you that really scares the shit out of you. I saw a little of it just a minute ago. You know, when you were trembling, your voice was quaking. And as crazy as these men...

HILDA: You mean, like I want to get wrapped up in their problems because I can handle theirs easier than I can handle my own?

THERAPIST: That's right. That's what. I wish I could have said that as well as you.

HILDA: That's true. I can take care of all of their problems for them.

Comments: The initial scaffolding of an alternative gallery is established. To review, the session began by focusing on two frames about Hilda's problems, connecting these frames, and moving them toward an alternative, more resourceful gallery, "Hilda's Crazy Solution":

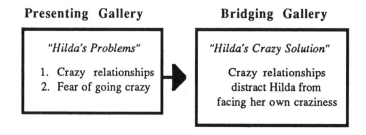

Presenting Gallery	Bridging Gallery
"Hilda's Problems"	*"Hilda's Crazy Solution"*
1. Crazy relationships 2. Fear of going crazy	Crazy relationships distract Hilda from facing her own craziness

It should be noted that "Hilda's Crazy Solution" is only a bridging gallery along the conversational path toward a therapeutic gallery. "Hilda's Crazy Solution" is not a well-formed therapeutic gallery because the frames hanging in it are not experienced as a resource by Hilda. What is resourceful about this gallery is that it shows Hilda how one problem may be a solution for another problem.

The therapist will now begin reversing the meaning of Hilda's craziness as a way of creating an opening to another gallery. This could have been done in a variety of ways including simply asking her, "How is it, Hilda, that you came to know your craziness as something scary rather than something creative?" Or the therapist could ask, "How is it you came to believe you have a stupid craziness as

opposed to a smart craziness? Smart craziness can earn you a living." Note how the therapist goes about reversing the connotation of Hilda's craziness:

THERAPIST: I don't want to make this sound like, like those parts of you that you're having trouble dealing with are anything that you really need to be afraid of because they are not. And I think that in the future, as time passes, you are going to discover that those things about you that you really are a little scared of -- let's put it that way -- are really wonderful resources and things that make you so unique and make what you have to offer, ah, exciting and so wonderful and worthwhile. But you don't need to rush into that and you need to just put that on hold for right now. And right now you need to just continue what you're doing with the men in your life, okay? Because, you know, we don't need to rush.

Comments: The therapist will continue with this effort to reverse the connotation of craziness until Hilda begins speaking of her craziness in a different way. When she makes this shift, the opening, "Hilda's Creative Gifts" is created, inviting therapeutic discourse to move out of the bridging gallery, "Hilda's Crazy Solution."
The therapist is ready for this opening and when it appears, he will ask Hilda about who in her family would be most upset if she were to fully develop her creative gifts. This moves the conversation into another gallery, "Hilda's Family."

HILDA: But it's like if I were to really, you know, get into this gift or whatever you want to call it, you know. I would feel like I was giving too much time and attention to me and not enough to other things. You know, more important things.
THERAPIST: Who would be most upset if you became, if you really let your creativity flow? And you really truly let (out) the genius that you think you can be and I think you can be. Would anyone be upset?

HILDA: Well, in my family my brother is very successful. My sister is well on her way, and I'm the fuck up of the family. Because if ever I would have something going right, I would do something to screw it up now, whatever it takes.

THERAPIST: Yes, and how does the rest of the family hear about that?

HILDA: How do they hear about it? Well, they see it.

THERAPIST: Who sees it first?

HILDA: My mother, probably. My father would be quiet because he never was one to push. But Mother always expected excellence, you know. And she only got it from "golden boy" and Diane.

Comments: Within the gallery, "Hilda's Family," the therapist elicits the frame that Hilda's mother would be most upset if she actualized her creative gifts. This led to frames about Hilda calling her mother quite frequently on the phone to complain about her problem relationships. When the therapist asked for other frames about her mother, Hilda gave a history of her mother's family, explaining that most of her relatives were destroyed in Hitler's concentration camps. The conversation continued:

HILDA: And this is important to me. My mother is the last, um, okay. My mother and her line, okay? All her brothers (she had one brother), mother and father, cousins -- everybody is dead. Now that was during Hitler's reign, okay? All these people died, okay?

THERAPIST: Right. In gas chambers.

HILDA: Okay, so they are all dead. Now I'm the only one, you know, and of course it breaks. When she married this man, then they had my brother and sister.

THERAPIST: So you're the last of the line.

HILDA: I'm the last of the line.

THERAPIST: And your father, what happened to him?

HILDA: He, also the war.

THERAPIST: The war got him? And it was your mother's father that died in the old folk's home?

HILDA: It was her mother, uh huh. They gassed everybody in the old folk's home.

Comments: At this point, the session has moved through the following sequence of galleries:

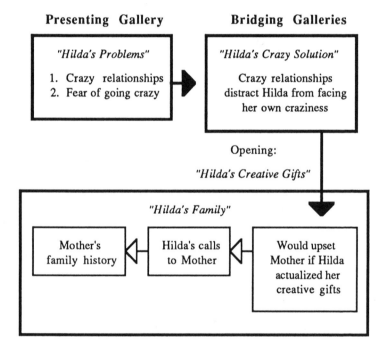

At this point, the therapist will *weave* together all the frames hanging in the bridging gallery, "Hilda's Family" so that this gallery can be transformed into what will become the therapeutic gallery, "Family's Crazy Solution." Into this therapeutic gallery, the therapist will also *weave* the frames originally

hanging in the bridging gallery, "Hilda's Crazy Solution."

THERAPIST: In the previous sessions, perhaps we had not fully appreciated the greater context and the greater -- the whole situation -- when we were looking at the problems that we were talking about. And that in one way, it seems to be very true that you involve yourself in one relationship after another as a way of distracting yourself, preoccupying yourself so that you don't have to look at you, and look at all the things that you can be. Ah, all the wonderful future you could have as an artist, and so forth. But that, as true as that is, when we look at some of the information that you have now given us about your family and your mother and the connection that you have with her, then even more so it seems that is true in regard to your mother. With her, she's lost everyone. In her life, you're the last one in her family and it must be a very frightening thing for her, the possibility of being hopeful for the future like she probably was before the war.

And I can only imagine the anxiousness that she must feel every time it looks like you are going to have a very bright future. Because just think of all of those things that could go through her mind about, "Oh my gosh, what if it happens again!" You see? And so, consequently, the solution is -- one solution is for you to almost have a very nice relationship. Because we are not sure that your mom could handle the anxiousness around the hopefulness of your succeeding and having this family go on.

HILDA: Well, I know she used to tell me that she could have given me up for adoption very easily. Because, you see, my father died before I was born -- right before I was born. And the reason she cannot be hopeful is because I'm the end of the line and there would be no reason to?

THERAPIST: The reason she can't be hopeful is because the last time she was hopeful, her heart was broken because she lost everything. And every time the

future starts really looking hopeful, it frightens her to death because the last time it broke her heart.

> *Comments:* The therapeutic gallery, "Family's Crazy Solution" has been constructed by carefully *weaving* frames and galleries in the following way: At first we thought these crazy relationships were a crazy solution that helped distract *you* from facing your own craziness. Now that we have broadened our view to see you in the context of your family, we have another idea: Talking about your crazy relationships with your mother helps distract *her*. Distract her from what? Distract her and protect her from having too much hope. The last time your mother had a lot of hope for her family, her heart was broken. She lost everyone she loved. She can't afford to be that hopeful again. If you keep complaining about your relationships with these men, she won't be able to get very hopeful. This protects her from having to be heartbroken again.
>
> The therapist continues, inviting Hilda to enter the emerging therapeutic gallery, "Family's Crazy Solution":

HILDA: Why is it so different for my brother and sister? Just because they have a different father?

> *Comments:* When Hilda sets forth this rhetorical challenge, note how the therapist will *weave* it as further evidence supporting and confirming the therapeutic gallery.

THERAPIST: It's very different.
HILDA: They have a living father?
THERAPIST: It's very different because you're the last of the line. You're the connection to all the people that died in the war. And it is very different. You are truly your mother's daughter.
HILDA: Yes.

THERAPIST: You see? and (it's) the one thing she can't -- and maybe she doesn't, and probably she doesn't -- recognize. I don't know. I don't know her.

HILDA: My mother probably doesn't know.

Comments: Hilda is indicating she is in the web of the therapeutic gallery.

THERAPIST: But (she) probably doesn't recognize that being hopeful, having a hopeful future for her family is a very frightening thing. Because the last time this was happening -- just think of what was happening -- she lost everyone. She lost the father of her child, she lost her parents, she lost everyone who was meaningful to her. And it scares her to death, the whole thought of having a hopeful future.

HILDA: Um hmm.

CO-THERAPIST: It even, it sounds like in the past she has even acted like you told...she was cold...

THERAPIST: Sure.

HILDA: She's very cold and she doesn't want anyone else in the family.

Comments: At this point, an intervention is designed to help keep Hilda in the emerging therapeutic gallery, "Family's Crazy Solution". She is asked to visit her mother who lives 400 miles away, and arrange to show her two paintings -- one that is "very hopeful" and another "not hopeful." This will give her the opportunity to observe how her mother reacts in the face of hope.

THERAPIST: Having a hopeful future just scares her to death. So we have an experiment we would like you to try out between now and the next time we meet. And this isn't trying to show your mother anything. It's more, we are just kind of going investigating; kind of looking around like a Sherlock Holmes to see what you can pick up; detect some things. You're an artist.

HILDA: Um hmm.

THERAPIST: Are you a painter?

HILDA: Um hmm.

THERAPIST: Have you some of the things that you've painted at your home?

HILDA: Um hmm.

THERAPIST: If you would look through and see if you can put your fingers on some of the things that you've painted that really are hopeful looking -- really nice, bright, futuristic, hopeful kind of things and put them there. And then look through and see if you can put your fingers on some that look hopeless. Things that really look dim and don't look very hopeful at all. And select two. Select the one most hopeful looking one and select the one with the least hope. And go show them to your mother and talk with her about them. And just, without leading her into it, just get her reaction to the hopeful painting.

CO-THERAPIST: Don't tell her which one is which.

THERAPIST: That's right, don't, don't...

HILDA: Well, I could. I mean I could go this weekend, but that would mean...I just don't want to see them. I just don't want to see them.

THERAPIST: Why? Is it kind of hopeless?

HILDA: You know, they are getting older and I don't want... I mean they're not old people -- my momma is 55. I mean my dad is 55, my mom is 59. I don't want to see her. Every time I go home it seems like they are getting to be old people and I don't want to see that.

THERAPIST: I mean, every word out of your mouth -- it just kind of confirms...

Comments: One technique of weaving involves always beginning one's response with "that confirms" or "that's what we're talking about" or "it fits better now." If the therapist isn't sure how the client's new frame can be woven in, he or she can go back to the presenting gallery and retrace with the

client all the galleries therapeutic conversation has moved through. Very often in this re-telling, the client will either forget trying to understand how the new frame fits, or more interestingly, will interject into the therapist's telling of the story how the frame fits. Even more fascinating is when the therapist surprises him or herself by capturing a way of explaining how the frame fits as the story is being told.

HILDA: And see, like I know, I know eventually she's going to leave and uh...

CO-THERAPIST: What do you mean, she's going to leave?

THERAPIST: Well, I've got my ideas if she's getting old.

CO-THERAPIST: She's 59.

THERAPIST: All the more reason to go down and take kind of a barometer reading here with the paintings. Because what better gift could you give to a mother growing old than the gift of hope?

HILDA: I knew you were going to get to it eventually. *(begins weeping)*

THERAPIST: Sure

HILDA: They ask...

THERAPIST: Do you hear what I'm saying here? You've got a chance to do some testing and finding out.

HILDA: I'll do...I'll do something on it. One way or the other I'll do something on it. I'll come up with the answer.

THERAPIST: Umm...We don't want -- listen now -- don't push yourself. We are not... this is kind of a test, that's all. Just kind of an experiment, you know? A hopeful picture, very bright, hopeful picture and a hopeless one. And just go down and test it out because I think you might be rushing here. She is only 59 after all. You know most women do live to be in their 70's in America. So, you know, let's not push...

HILDA: And she is healthy. Real healthy.

THERAPIST: Sure.

HILDA: Healthier than I am, but um, it's just...you know. When I was at the hospital that time, they told me to describe how I see my mother. And I said, well, she is ice cold. She has very sharp edges, very shiny black. Almost like marble and almost like pointed at the top. It's got like, maybe, six sides to it and each one is very pointed and very sharp and very piercing and so black and so cold that it looks almost shiny and metallic and silver.

THERAPIST: This is a psychiatric hospital you were in? I work in psychiatric hospitals. You know what they remind me of?

HILDA: What?

THERAPIST: They remind me of concentration camps.

Comments: This frame begins setting up a further connection or similarity between the lives of Hilda and her mother.

THERAPIST: Now, we are not suggesting and we really don't suggest that you go and disclose or talk to her about any of this that we are talking about here.

HILDA: I understand.

Comments: The intervention is now refined to more tightly fit Hilda's concerns.

THERAPIST: You could even go and tell her you are going to see if you can sell some of the paintings. Austin is a good place to sell paintings. And you can go and just elicit what are her reactions to some of the paintings. But choose for yourself a particular one of yours. One of your paintings that really expresses hope, and be sure to bring that one. And bring one that looks dismal and is rather hopeless and bring that and present them to her. And just kind of feel her out. "What do you think about these?" Get an idea of what her sense of hope is when she is looking at the hopeful

painting and when she is looking at the hopeless painting. And you don't have to stay long. Just stay for a short time and then come back. And let's talk about it in about two weeks.

CO-THERAPIST: But the main thing, just to reiterate that, is how is she going to look in the face of hope? And we'll go two weeks.

The Next Session

HILDA: Well, y'all are going to kill me because I have not got the information for you that I was supposed to get.

THERAPIST: You were not able to go, or didn't go to Austin. Have you talked to her on the phone?

HILDA: Yes. I did and I finally managed to get out an "I love you," and it was real broken. And I felt so phoney. After I did it I felt like... not that I don't love her: I think I love her but I think it is an obsessiveness almost. It's, I want to possess her, ah... I'm so afraid she's going to leave, you know, walk away and I won't ever see her again. And the age does that -- her age. I can see all this happening and it scares me.

THERAPIST: When you talked to your mother did you talk about Leonard and the problems that you're having?

HILDA: Yeah. She tells me get rid of Leonard. Get rid of any guy, like, that has problems like that. Get someone that has more of the right things going for them at the time.

Comments: The consultant suggests that the therapists ask Hilda how much she thinks she is like her mother.

CO-THERAPIST: Hilda?
HILDA: Yes, sir?
CO-THERAPIST: How much do you think you are like your mom?

HILDA: *(sighs)* Exactly, yeah... *(begins weeping)* Like this picture right here. *(points to reflection in mirror)*

THERAPIST: How does it connect in how you stay connected with your mother?

HILDA: If I did something wrong, I would do anything to get back in her good graces, you know. To get her not to think of me the way she was thinking of me. Or, not to threaten to leave like she always did. That was her favorite. Anything I did to misbehave, she would say, "If you don't stop this, if you don't straighten up, I'm going to leave and you will never see me again." You know, as a child the only thing I really saw -- like I guess maybe four years, three years old, something like that: I remember my mother walking away from, getting ready to leave to go somewhere. Now this was not one of the threats, okay? This was actually leaving. And I would just grab on to her leg and scream bloody murder, "Don't leave! Don't leave!" I mean, she had a real problem with me with this. And it never stopped. It went on and on all through.

Comments: We find that Hilda feels she is exactly like her mother in that both women are afraid of significant others leaving them. "Mother and Hilda are identical" gives the therapist more frames to weave into the therapeutic gallery, "Family's Crazy Solution":

THERAPIST: You see what's happening here? I want to make sure you see what's happening. That what's really happening is that you are, unknowingly, reliving your mother's life here. That...

HILDA: Then what is my fear? What is the fear I have?

THERAPIST: When your mother first experienced hope, she lost it all and she was literally heartbroken because everyone left her. Everyone left her except her daughter. The last of the line. And just as your mother fears hope because it reminds her of the last

time it happened and she was heartbroken, the same thing is happening in your life with these men. You're repeating the very same pattern that your mother repeated, which is that you get very close and then when things start looking hopeful, ah, when things start actually becoming hopeful, you pull back because you're afraid that you might lose this person and you will end up heartbroken.

HILDA: When things become hopeful?

THERAPIST: Yeah. When things start looking like they are hopeful, like things are going to work much good in your life, something always happens. You said that something always happens.

CO-THERAPIST: That's because she is afraid of losing.

THERAPIST: And you're afraid of losing. Just as your mother's afraid of losing. You're afraid of the heartbreak involved in hope.

HILDA: But when does it ever stop?

THERAPIST: Okay. Let's just make sure, though, before we go into that, right, that we have a good feel for this whole thing.

HILDA: I understand what you're saying. But I feel, I feel like the clock is ticking and something is going to happen and...*(begins to cry)*

Comments: Hilda is clearly asking for an *exit marker* to point the way out. The therapy team offers it in the form of an intervention which is based on all the frames contextualized in the therapeutic gallery.

THERAPIST: I, you know it's dumbfounding sometimes how much we don't see as a team here working with you and how we underestimate the complexity of the situation. Our asking you to go bring those pictures to your mother two weeks ago was, at best, premature. We jumped the gun and you clearly were not ready for that yet. But we do have an idea of something that could be helpful. And it is this: We still need to get you to talk to your mother a little and get

some feel for that. What we would like you to do is, sometime this week, to call your mother on the phone. And to tell her that you had a dream. And it is a very disturbing dream and you can't get it out of your mind. And you want to talk to her about it. And maybe get her to help you with this dream.

HILDA: Um hmm.

THERAPIST: To understand it. And tell her that the dream has three parts. And it starts out that in the dream you're a little girl. And you're growing up and you're with your mother, and as you are growing up, you're a little girl and you're crying. And you're afraid that your mother is going to leave and so you're clinging and you're holding on to her arm. And that is how the dream starts. And then you hear a voice and the voice says, "You can't afford to have any hope." And then in your dream, the scene shifts and you are now a young woman. Like you are now. And you're involved with men. And in each of the relationships that you are involved with, you're holding on to their arm, and you're very scared that they are going to leave. And again you hear the voice. It says, "You can't afford to have hope." And then that scene fades. And another scene comes into your mind in this dream. And in that dream, in that scene, you're a different woman. But you're still crying and you're afraid. And you see all of your friends and all of your family and loved ones, those who are important to you. They have all left you, okay? And you look up and you see that your family and your friends that have left you...they have all been gassed in the prison camp. And then you realize that you are your mother.

HILDA: Um hmm.

THERAPIST: And then you hear a voice. And the voice tells you that your mom must teach you how to have hope. Okay?

Comments: The therapy team wrote the dream out on paper so Hilda could accurately relay it to her mother.

The Final Session

HILDA: I made a phone call and everything, and did talk to her about it.

THERAPIST: Oh. And so?

HILDA: As far as my art work, I also went over that, and she just thinks that I need to stick longer with things. That I start things and then don't finish. I guess it perturbs...

CO-THERAPIST: Did you take some of your art work with you?

HILDA: It is mostly at her house anyway.

CO-THERAPIST: Did you take down one that looked hopeful and one that...

HILDA: Okay. She has pretty much all of my stuff. And she, you know, it's just she does not like my graphics. I mean she never will. It's just not her. But the landscapes and things she loves. So she won't change that. But she thinks I ought to stay with it more and refine it more.

THERAPIST: The painting?

HILDA: The painting.

Comments: Hilda has done the assignment given two sessions ago. The therapist now asks her about last week's assignment.

HILDA: Okay, I told you I had to talk to her on the phone and I have to ask her the things about my dreams, right?

THERAPIST: Yeah.

HILDA: And I did. And after that I said to her, "Mom, I just had another crazy dream..." And this is true: I used to always dream that there was a wishing well and Mother cannot swim, okay. "And I always dreamed that you were looking in the wishing well to see what was in there and that you fell in and that you died. And this was a dream I had for many years." And she said, "Really? I died?" And I said, "Yeah, you died." And she said, "A wishing well, huh?" And I said,

"Yeah." And I don't know what that would mean. I don't know if I wish her to die. I don't understand that.

Comments: Everyone is being inducted into the therapeutic gallery -- Hilda and the therapy team.

THERAPIST: Hmm. Well, how did she respond to the dream?

HILDA: Uh, the three different...?

THERAPIST: Um hmm.

HILDA: Okay. I said, "Mom, you know I've been having these strange dreams and I've got to tell you about them." Okay, 'cause I used to tell her about my dreams anyway. And I said, "One of them was when I was a kid and you were getting ready to leave and I was grabbing on to your arm." And I pretty much...I had my paper in front of me, you know...had it underlined. I said, "And the voice said there was no hope." And my mom is a very loud person. Not loud, but she says what is on her mind. And she said in kind of a quiet voice, "No hope?" Kind of like, "No hope?" just in a smaller voice -- a different voice. And it is the voice I hear when she doesn't....either doesn't like what she hears or something that scares her a little bit, okay? It's that voice in her. Then I went to the second dream and I told her that the voice again said, you know that there is not a hopeful future, or whatever it was. I went by the paper. And she said, "Really?" And she was just listening intently. And then, of course, I read all the details of the third one and said at the third one, "Mom, it was a different woman and it was, um, it was not me." Then I went into the paper again and that woman was her, right? If I remember right.

CO-THERAPIST: You were her.

HILDA: Yeah. I was her. And in this one it turned out that there was a hopeful future and you're trying to get her to tell me about it. And she says...she did not give me the response I wanted to hear. She almost, like, avoided it. She almost, like, didn't answer it except what she had to, which was, "Oh, really?" Or it

was not what I thought she would say. She...she's very defiant.

CO-THERAPIST: Mother was to teach you to have hope.

HILDA: Um hmm.

CO-THERAPIST: And she didn't respond.

HILDA: And she... she was just real quiet. And my mother is just... is very antagonistic. She will argue a point into the ground. But she couldn't argue. She didn't argue with me at all.

> *Comments:* The therapists at this point tell the entire therapeutic story to Hilda, moving through all the previously constructed galleries and weaving the new frames she has presented. At the end of this story, the therapist will suggest moving away from any further elaboration of understanding and propose a new course of action for Hilda.

THERAPIST: Well, the team, and so are both of us, believe that your mother's response to the phone call just really confirms everything that we have been talking about. And we think that we have got a pretty good handle on understanding the reasons for all of your situation. And so what I want to do is give you a real brief summary -- it won't take long -- of what we have done to date.

You know, of course, when you first came in, that the main thing on your mind was the crazy relationships that you were having with men -- one after another. And we were able to see how this was, in fact was actually a distraction to keep you from focusing on the creative parts of yourself that you didn't understand. And then as our conversations continued, we were able to, later on, see how your talking to your mother on the telephone about these relationships actually did more than distract you. It also distracted...helped your mother by distracting her from facing hope. Because the last time she faced hope, everyone in her life she lost, and she was heartbroken.

HILDA: Um hmm.

THERAPIST: And then last session we were able -- you were actually able -- to see how you were just like your mother. And in a lot of ways, how you are like your mother is that you are both very afraid of being heartbroken. And that's how you're kind of living out her life in yours. Your mother was heartbroken when she lost her family in the war. And when you were a little girl, I remember you telling us the story of how you would be just petrified when your mother would try to leave and you could not stand -- tolerate -- the heartbreak you thought you might...

HILDA: I was thinking about that, though, you know. And...

THERAPIST: Let me just go ahead and finish this and then we will go into that, okay?

HILDA: Uh huh.

THERAPIST: And in the present situation, you are doing the same thing, in essence, with men and have been doing that. And so actually, it is the same old song. And it is a way... And of course you would call your mother and talk with her about these things. And that would keep her from getting too hopeful, because if she is too hopeful, it's too close to the heartbreak she felt once. And this has been going round and round and round, and I think that we understand this. And there is really not much more to know about this cycle because it is the cycle of your life that's gone on. And so we are going to suggest something to you. And it is this: Every time you find yourself worrying about men or your mother, or other people in your life leaving, what we would like you to do is go paint or sculpt at that point.

Comments: The therapist emphasizes that the therapeutic conversation has brought about the understandings necessary to help Hilda get on with her life. By suggesting a new method for handling her concerns about others leaving, Hilda is invited to enter a more resourceful frame within the therapeutic gallery. The complete case score follows:

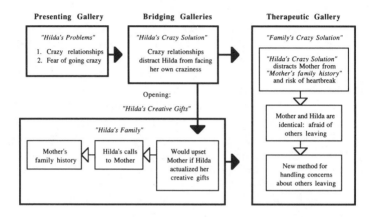

THERAPIST: So paint or sculpt because that's the one thing that -- even if these others might leave, because people leave -- this is one thing they can't take from you. It's your creativeness, and so paint or sculpt. And as you are doing that -- and after you have actually done that, done some painting -- then call your mother. Okay?

HILDA: um hmm.

THERAPIST: And then when you are talking to your mother, don't talk to her about the men. Talk to her about your painting or your sculpting. And talk to her about how frustrating it can sometimes be when you have got these ideas in your mind and you have a hard time translating them to the painting or to the sculpting. And how -- and couch this in terms of not being hopeful at all about the painting -- how you feel like you will never quite get where you know you can be in painting and it's quite hopeless, actually. And never mention men. Because she will... she'll mention the men and when she does, you play it down. Say to your mother,

"Oh, well, you know, I've stopped worrying about them because I know I can't control what they do, and I'm not going to worry about that. I'm focusing myself on something that people can't take away from me, and that's my wonderful creative gifts."

There will be those times when you'll be worrying about someone and you just won't be able to get the creative energies going and you won't be able to paint. So when that happens, go ahead and call your mom at that point. But say to her...worry with her about the fact that you're having a hard time getting your creativeness going -- that you are trying to paint and you are getting frustrated. You are not able to get out what you're wanting to do or say. And then do the same thing that we said before -- don't mention the men. And you play it down again. Say, "Oh, well, I'm not worried about that. What I'm frustrated with is the fact that I know I've got these creative gifts and I can't... right now I'm not getting them out." Okay?

HILDA: You know, I must have made some good points with my mother when I was home because, you know, I lost a lot of family pictures. We are talking about way back -- the 1800's and up. I lost a bunch of them a couple of years back... somewhere when I moved. I don't know where they went. But anyway, you just can't replace them. But she had a lot more of them -- of the Nazi soldiers -- and just so much of it, you know. And she told me I could take two of the scrapbooks with me because, number one, I wanted to show Leonard, you know... and just take time to look at them.

THERAPIST: My. So she gave you hope after all.

HILDA: So she let me borrow them for a while. I have to give them back, of course, which I want to. But she actually let me have them to look at, and so on.

THERAPIST: That is fascinating. Let me think about that one. That's worth knowing. Thank you. With the holidays coming up, we probably need to take a

longer break. What do you say about seeing you four weeks from now?

HILDA: That is a long time.

THERAPIST: Well, we are as close as the phone.

HILDA: I know, but I would not call you. I needed to call the other day and I wouldn't do it 'cause it is out of schedule, you know. And I wouldn't want to bump anybody else.

Comments: The consultant intervenes suggesting that Hilda is now concerned about the therapists leaving her. This provides an opportunity for weaving the therapists into the therapeutic story that has become Hilda's Gallery.

THERAPIST: There were two things that... Your feeling a little unsure about not coming back here for a month is very much like the other things that you are feeling unsure of.

HILDA: I just thought about that.

THERAPIST: You have mental connection with the fellow behind the mirror, then, because that's what he was thinking, too. So, when you start feeling that between now and next week, use it as an occasion to sit down and get into your painting or your sculpting. And really focus on the one thing that no one can take from you... and that is the creativity. And if you really want to, you could send us a small sketch or something in the mail. But what we would really like to see you do -- a month from now when you come back -- is bring an example of your art that you do between now and then to show us. Okay?

Comments: With the last intervention, the therapeutic gallery is complete and well-formed. Therapeutic discourse has transformed Hilda's initial fears and concerns into being the very resources that could help her (and her mother) fulfill their lives in a more enriching and nurturing way.

Over the next several months, Hilda returned for brief sessions, pleased that her life was under control, and that she was successful in handling her problem relationships. Several times she mentioned that she wasn't yet ready for the therapists to see her art. A colleague suggests that the best definition of a successful outcome for Hilda will be when her paintings and sculptures move from the gallery of a hospital's showcase to a professional art gallery.

Chapter Seven

CREATING ONE'S

OWN CLINICAL STYLE

Perhaps the most radical argument of this book is that the teachings and writings of the inventors of so-called "schools" of therapy are not necessarily good for the therapist's health. Schools of therapy are born when the inventor simply orchestrates a way of utilizing his or her individual resources at the time in which the text was written. The text, as a record of how someone momentarily created a personal style, is an interesting document that deservingly appeals to the curiosity of other therapists.

Unfortunately, when the author of such a text begins believing or acting upon the premise that his or her work is *the* general roadmap, prescription, or recipe dictating *the* correct, best, true, or most useful way of conducting therapy, the text becomes iatrogenic. It may become toxic not only to the creativity of other therapists, but may also destroy the imagination of the author/therapist who wrote it. The field of psychotherapy is full of too many stories about leading therapists who keep repeating the same performance (intervention, style, explanation, or book) time and time again, becoming less and less imaginative and less and less alive.

Therapists who have "burned out" their creative lives too easily fall victim to the seduction of greed and power, and through their political conduct manage to trivialize the whole mental health profession. To confirm for themselves that their way is right or best, they go about assembling an army of predictable therapists -- therapists cloned in the image of the dead leader.

This book invites therapists to consider the gross stupidity, symbolic cruelty, and toxicity of inflexible schools and teachers of therapy. The "Amway-like" cliches and slogans of the delusional workshop performer are the prophetic declarations of a time when therapists first lose their imaginations, and then lose themselves. Anything that smells of sophomoric generalizations, cheap entertainment, and fundamentalism, whether in politics, religion, or therapy is a sure sign of an assault on your own resourcefulness.

This chapter describes a way of reorganizing clinical training and consultation to focus on tapping the uniqueness of each therapist. It begins with a thorough assessment of a therapist's personal style, resources, and even so-called "limitations." (Remember, limitations, when appropriately used, are often one's greatest resources.)

A list of questions in the "Therapist Resource Assessment" helps therapists identify what they bring naturally to therapy. The assessment can be used by the therapist or by the therapist's consultant to create an outline of the ingredients or resources a particular therapist has to work with. These resources are then sorted and orchestrated into a general style that fits the therapist's performance preferences. The chapter provides a brief case study exemplifying how one therapist created his own clinical style.

Determining a therapist's resources begins with administering the set of questions that follow.

Therapist Resource Assessment

1. Of all the existing schools of therapy, if you had been the author or inventor of one, which would you select?

2. Do you enjoy telling stories?

3. In rank order, which of the following words best characterize your style of relating to clients?

mothering
fathering
coaching
instructing
directing
doctoring
nursing
choreographing
others (please specify)

4. Think of several therapists you know whose work you admire. Make a list of what they do that you wish you could do.

5. What one word best characterizes your work as a therapist?

6. If you were to attend a school for the performing arts, what theatrical skill(s) would you want to learn the most?

7. Think of your favorite therapeutic techniques. Choose several words that best convey what these techniques have in common.

8. Fantasize directing a movie entitled, "The World's Most Successful Psychotherapist." Use a brief phrase to describe how you would choose to characterize this therapist's work.

9. What one word is the least descriptive of your work? Now, what is the opposite of that word?

10. Do you place a high value on interpretation in therapy?

11. Do you usually try to have clients define a *problem* to work on?

12. If you attended the most rewarding and meaningful workshop imaginable, what would be its title?

13. Make up a title for a book on psychotherapy that you would go immediately to a bookstore to purchase.

14. If you could spend several hours with any therapist, deceased or alive, who would it be?

15. If you had to teach a course on psychotherapy and could use only one book, what would it be?

16. Imagine writing a book on psychotherapy. What key word would be listed most frequently in the index?

17. Imagine writing to the therapist you respect most and asking for a one-sentence summary of advice. What's your best guess as to what would be said?

18 What is it about you that people enjoy the most?

19. What one word best describes how you communicate?

20. If you were to be cast in theatrical plays, what kind of characters would you portray best?

21. Imagine having a fan club of admirers who regard you as a brilliant therapist. What would they find most admirable about your work?

22. If you were to conduct a one-day workshop on "the art of effective psychotherapy," what would be the general outline of topics you would present?

23. Invent a therapeutic case story that would exemplify the way you would like to work as a therapist.

24. Choose a story or movie you are familiar with in which a major problem takes place. Create a way of solving it if your service as a psychotherapist were inserted into the tale.

25. What genre of humor do you think you're best at conveying?

26. Make a list of all the schools or orientations to therapy you know something about. Next to each name of a therapy, write the one word best characterizing it. Rank order this list in terms of importance, however you define it.

27. How important is it for you to explore "history" in a case?

28. How important is it to focus on the "here-and-now"?

29. Do you enjoy giving directives, tasks, or homework?

30. Do you enjoy a sense of the absurd?

31. Are you more "rational" or "irrational" in your work?

32. How important is a "sense of play" in your work?

33. What are the most outrageous things you've ever done in your therapeutic work?

34. What kind of people do you enjoy working with the most? Using one word, characterize what you do with these clients.

35. Think of three cases you've conducted in the past. Create a fantasy about what you could have done differently with those cases to make them major contributions to the psychotherapeutic literature.

36. How important is "social context" to your therapeutic work?

37. If you spent five years training under the top dozen therapists in the world, describe three things you think you would learn.

38. What's the best advice you can give to a beginning therapist?

39. What's the best question you can ask a seasoned therapist?

40. In one sentence, define the most positive characteristic of your speaking style.

41. What's the most positive statement you can make about your listening style?

42. Which movie star, living or deceased, would make the best psychotherapist?

43. If you wrote three tips to keep you at your best in therapy, what would they be?

44. What themes in therapy are most interesting to you?

45. What are you most curious about in the realm of human experience?

46. In one sentence, what is the most mysterious aspect of psychotherapy?

47. What do you like best and least about your clinical office?

48. If you could hire an expert to design your clinical office, what changes can you fantasize being made?

49. If you weren't a therapist and had to choose another profession, what would it be?

50. If you were asked to write one intervention that you could give to every client entering your office, what would it be?

51. If you were asked to write one understanding or interpretation to share with all clients, what would it be?

52. Name three things you would never talk about in a session.

53. Name three tasks you would never ask a client to perform.

54. Are you "wild" or "tame" in your finest moments of therapy?

55. Is your best work chaotic or clearly organized?

56. When you are getting to know a new therapist, what clinical stories do you tell about your work?

57. What are your favorite case stories about someone else's work?

58. What are the three most special memories you have of your clinical work?

Designing One's Own Clinical Style

After completing the "Therapist Resource Assessment," the therapist will have a comprehensive list of a variety of personal resource frames. The next step is to take all these frames and organize them under more general categories. A concise and simple way of doing this involves sorting the frames into two groups -- one pertaining to *beliefs and understandings* and the other to *therapeutic actions.*

In this sorting process, major resource frames emerge which can then be used as building blocks for

designing a therapeutic strategy, approach, or style that is unique to the particular therapist. An example of how to design one's own clinical style follows:

Powell is a 57-year-old psychotherapist who is in private practice and also holds a leadership position in a chemical dependency treatment program. He was a star athlete in his youth and the minister of a church for most of his career, but a drinking problem led to an existential crisis and change in profession. As a "recovering alcoholic," Powell finds his work in helping other "recovering alcoholics" to be therapeutic in maintaining his own sobriety and sense of meaningfulness.

After eliciting his responses to the "Therapist Resource Assessment," the following frames were found to constitute the major ingredients Powell uses in his work as a therapist:

-Conviction that most psychotherapy is "crap"
-Natural rapport
-Mastery at working with "emotions", e.g., discussing feelings
-Prodigious ability to provide pastoral, father-like caring
-Master storyteller
-Sense of the absurd
-Intoxicated with humor, particularly vulgar humor
-Always keep it simple

The next step is to sort these resource frames into the two groupings, *beliefs and understandings* and *therapeutic action:*

Beliefs and Understandings
Psychotherapy is crap
Sense of the absurd
Simplicity for client

Therapeutic Action
Natural rapport
Works with emotions (e.g., discussing feelings)
Pastoral, father-like care
Storytelling
Humor (particularly vulgar)

With the sorting process complete, we turn to using the major resource frames to orchestrate a personalized clinical style. This is done by sequencing the major resource frames. That is, the therapist creates a basic pattern of how he or she will use resource frames in the course of therapeutic conversation.

For example, the pattern for Powell's therapeutic style is created by orchestrating his major resource frames in the following sequence: He begins therapy by socially connecting and achieving rapport with the client. When this is established, Powell moves to the stage of discussing feelings. Here the therapist-client relationship is intensified and trust is established. With this increased connection, the session moves to the stage of "the sermon" where he tells the client three important things that should always be remembered:

1. Most of the past and future advice you have received or will receive is *nonsense*.
2. Whatever it is that will work for you, one thing is certain: it will be simple.
3. Never forget to laugh.

With this brief message, the final therapeutic stage is initiated. Here Powell begins by sharing a joke. Next some simple advice is given, perhaps an idea to think about or a task to carry out. And finally, he tells a serious story that provides the dramatic highlight of the session. This fully orchestrated sequence thus provides the therapist with a personalized way of utilizing his own natural resources in therapy.

Therapists may reassess their beliefs, understandings, actions, fantasies, and desires on a

frequent basis, noting any different or new resource frames. Such differences lead the way to modifying the therapist's previous style or, in some cases, these differences may lead to the design of an entirely new therapeutic approach. Co-therapists or therapists working together in teams may assess one another and cooperatively construct therapeutic styles for each other's work as well as for the team. Similarly, this method provides a more individualized approach for therapeutic supervisors and consultants to use. Here, supervisors and consultants help therapists draw upon their own resources rather than trying to fit them into a template or model that was designed by someone else for someone else.

As a therapist becomes more skilled in identifying and utilizing resource frames to create therapeutic approaches and styles, a time may come when he or she is resourceful enough to design a unique therapy for each unique client. At this stage, the therapist will have fully matured into an improvisational therapist.

Chapter Eight

BEING AN

IMPROVISATIONAL THERAPIST

Psychotherapy is unquestionably the most challenging, frustrating, and rewarding profession ever conceived. No other way of making a living provides as many dramatic enactments of the human condition. As psychotherapists, fear, trembling, hope, exhilaration, tears, and laughter are daily visitors to our work.

Some have suggested that we offer nothing more than the weaving of words. As wordsmiths, we may feel impotent in the absence of concrete tools. Fear of such impotence tempts many of us to hide behind the comfortable propaganda espoused by psychopharmacological marketeers, institutions, and technologies of social control.

We should never underemphasize the extent to which human experience is contextualized, known, and created by weavers, carvers, actors, sculptors, jugglers, musicians, dancers, and players of words. The spoken and unspoken provide the differences that matter.

The therapist can choose to reject the lazy belief that the best way to help unpredictable clients is through drugs and closed walls. The way out is through awakening, cultivating, protecting, and nurturing imagination and creativity in one's self, family, colleagues, and clients.

Unfortunately, the most dangerous places for learning how to awaken one's imagination are often workshops, training centers, universities, and accrediting institutions. At the same time, these are the very contexts which, in spite of their shortcomings, provide opportunities for therapists to evolve. The

outcome is significantly shaped by whether the student has the courage to teach the teacher.

As all good teachers know, the students who really make a difference are always the most disturbing, challenging, and engaging. Their imagination is not anesthesized by obedience to bureaucratic rituals. They are compelled to be unpredictable to both others and themselves. If a teacher has the courage to encounter this creativity, he or she must change. The old pedagogical responses won't fit new questions. The teacher must respond with imagination.

Too often, teachers and students submit to the political game of being completely predictable (e.g., perfect exam scores), trivialized, unimaginative, and inhuman. Teachers and students are therefore both caught in the same dilemma -- they slumber in institutions whose primary purpose is to maintain the institution. The challenge is to wake up and dare to exercise each other's imagination.

What do we know about people who have not allowed themselves to become comatose enforcers of institutional politics, choosing instead to live in an oasis of creativity? One description stands out: they always have one foot outside the system and are often described as "troublemakers," "clowns," "radicals," "rebels," "mavericks," "outsiders," and so forth. They don't take the institution seriously enough. It is said they encourage others to be disrespectful of the traditions and rules. They can't be controlled. They're unpredictable.

Improvisation invites playfulness, unpredictability, creativity, and imagination. This is dangerous to anyone or any institution reluctant to change or afraid of upsetting the status quo. Yet this latter direction means the death of one's imagination, a condition that is easily dealt with by complete surrender to social control. The choice is present in every session for both client and therapist: whether to risk being alive, imaginative, and improvisational, or to retreat into secure slumber.

The introduction of surprise and unpredictability requires loosening the grip of understanding. What one understands can only lead to the further understandable, that is, the predictable here-future. In therapy, improvisation welcomes conduct without understanding. A little story plays with this point:

Once upon a time there was a therapist who had an absolutely amazing reputation. No one could track down what it was she said that was responsible for her clinical successes. Eventually, a distinguished choreographer was brought out of retirement to observe and study this therapist. After hours and hours of careful observation, he said, "It's obvious what's taking place. Look at her cigarette -- it dances!"

Sure enough, throughout each session, the therapist held a lit cigarette and elegantly moved it in rhythmic aesthetic patterns, creating a dance of cigarette and smoke. The cigarette was in synch with the therapeutic discourse, marking it here and there, pointing to entrances and exits, using it to underscore and distract, making connections, disconnections, and even some moves the choreographer had never seen before.

Everyone was delighted. The choreographer had gone so far as to conclude, "The cigarette is the therapist!" With enthusiasm, the report was shown to the therapist who read it with great curiosity. Even she was delighted to now understand how her therapy worked.

Then an unexplainable thing happened: From that day forward, she could not do the same kind of therapy. Understanding what she used to do had changed her. She was no longer that therapist. Now she was the product of combining who she used to be with an understanding of her prior work. She spent years trying to recapture her therapeutic style.

However, she was eventually able to see the wisdom of the choreographer's intervention, for she

gave up smoking, gave up trying to completely understand her therapy, and found she's unable to stop evolving new ways of dancing with words.

In closing, an assignment is provided for therapists who still think they want to discover the most basic, significant, and meaningful understanding one can have of therapeutic practice:

1. Make a list of the ten people who were most influential in capturing your imagination, inspiring your interest, and contributing to your development as a psychotherapist. This list may include people you know personally, or those you have not met, whose ideas, clinical tapes, or teaching have influenced you.

2. For each name listed above, write a sentence that best captures how each person contributed to your evolution as a therapist.

3. For each sentence created in Step 2, circle the one word that is most representative and most resonant with the intended meaning of the sentence.

4. Write one paragraph using only the words circled in Step 3. This paragraph will be your best effort to summarize the meaning of psychotherapy. It should be something you would be willing to argue for and stake your reputation or career on. Use only the circled words, except for articles such as *a, the, and,* and so forth.

5. Read this paragraph three times a day for the next three days. Then wrap it up neatly and place it in your freezer. Hide it where others won't see it.

6. The next time you're feeling like you might "burn out," go to your freezer, remove your paragraph, and thaw it out. When it's thawed, read it three times a day

for the next three days. Then wrap it up neatly and place it in your freezer once again.

7. Recall or make your best guess as to the first day you entered the profession of psychotherapy. Mark that date in your calendar as your psychotherapy birthday. Every year on this birthday, repeat the recipe for creating a paragraph of understanding. Put each paragraph on a separate page, folded in the same way as the previous year, and bind all understandings together for placement in your freezer.

8. Pass this procedure on to therapists who you think will benefit from using it.

A final caution about this assignment. Remember what happened to the therapist who was presented with an understanding of her work?

Do you really want to know?

References

Bateson, G. *Steps to an ecology of mind.* New York: Ballantine, 1972.

Chenail, R. Personal communication, April 3, 1990.

Field, S. *Screenplay: The foundations of screenwriting.* New York: Dell Publishing, 1982.

Goffman, E. *Frame analysis.* New York: Harper & Row, 1974

Keeney, B. P. *Aesthetics of change.* New York: The Guilford Press, 1983.

Keeney, B.P. & Ross, J. *Mind in therapy: Constructing systemic family therapies.* New York: Basic Books, 1985.

Keeney, B.P. & Silverstein, O. *The therapeutic voice of Olga Silverstein.* New York: The Guilford Press, 1986.

Lyons, L. *The great jazz pianists.* New York: Da Capo Press, 1983.

Taylor, B. *Jazz piano: A jazz history.* Dubuque, Iowa: Wm. C. Brown Co., Pub., 1983.

Watzlawick, P., Weakland, J., & Fisch, R. *Change: Principles of problem formation and problem resolution.* New York: W.W. Norton, 1974.